THE MIRACULOUS
FROM THE MATERIAL

THE MIRACULOUS
FROM THE MATERIAL

Understanding the Wonders of Nature

Alan Lightman

PANTHEON BOOKS, NEW YORK

All rights reserved. Published in the United States by Pantheon Books,
a division of Penguin Random House LLC, New York, and distributed
in Canada by Penguin Random House Canada Limited, Toronto.

Pantheon Books and colophon are registered trademarks
of Penguin Random House LLC.

Library of Congress Cataloging-in-Publication Data
Names: Lightman, Alan P., [date]- author.
Title: The miraculous from the material : understanding
the wonders of nature / Alan Lightman.
Description: First edition. | New York : Pantheon Books, [2024] |
Includes bibliographical references.
Identifiers: LCCN 2023056443 (print) | LCCN 2023056444 (ebook) |
ISBN 9780593701485 (hardcover) | ISBN 9780593701492 (ebk)
Subjects: LCSH: Science—Popular works. | Nature—Popular works
Classification: LCC Q126 .L54 2024 (print) |
LCC Q126 (ebook) | DDC 500—dc23/eng/20240223
LC record available at https://lccn.loc.gov/2023056443
LC ebook record available at https://lccn.loc.gov/2023056444

www.pantheonbooks.com

Book design by Michael Collica
Jacket photograph by Maria Vojtovicova / Unsplash
Jacket design by Mark Abrams

Printed in China
First Edition
2 4 6 8 9 7 5 3 1

CONTENTS

Contents

INTRODUCTION

I call myself a spiritual materialist. By "materialist," I mean that I believe the world is made of material stuff, and nothing more, and that material obeys rules and laws. At the same time, like many of us, I have "spiritual" experiences: feelings of connection to other human beings and to the larger cosmos, moments of communion with wild animals, the appreciation of beauty, wonder. Nature is capable of extraordinary phenomena. We human beings stand in awe of those phenomena. That's part of my view of spirituality.

I became a materialist early in life. Around the age of twelve or thirteen, I installed a laboratory in a large closet off my second-floor bedroom. There, I collected little bottles of various chemicals like potassium and molybdenum and sulfuric acid, petri dishes and test tubes, beautiful glass beakers and boiling flasks, Bunsen burners, motors of different kinds, a microscope and glass slides, resistors and capacitors, batteries, photoelectric cells, coils of wire of varying thicknesses and grades, delicate pipettes, filters and crucibles, voltmeters and ohmmeters, scales, pressure gauges, and random devices I'd found in the discard pile of an electrical supply store. It was in that home-made lab that I began my investigations of the material world.

I loved to build things. I read in *Popular Science* or some other magazine that the time for a pendulum to make a complete swing,

called its period, is proportional to the square root of the length of the pendulum. What a fascinating rule! But I had to see if it was true. With string and a fishing weight for the bob at the end of the string, I constructed pendulums of various sizes. I measured their lengths with a ruler and timed their periods with a stopwatch. The rule was true. And it worked every time, without exception. Using the rule I had verified, I could even predict the periods of new pendulums even before I built them. Evidently, the physical world, or at least this little corner of it, obeyed reliable, logical, quantitative laws.

In high school, in collaboration with a friend, I built a light-borne communication device. The heart of the thing was a mouthpiece made out of the lid of a shoe polish can with the flat section of a balloon stretched tightly across it. Onto this rubber membrane we attached a tiny piece of silvered glass, which acted as a mirror. A light beam was focused onto the tiny mirror and reflected from it. When a person talked into the mouthpiece, the rubber vibrated. In turn, the tiny mirror quivered, and those minute quiverings produced a shimmering in the reflected beam, like the shimmering of sunlight reflected from a trembling lake. In this manner, the information in the speaker's voice was precisely encoded into light, each rise and dip of uttered sound translating into a brightening or dimming of the beam. After its reflection, the fluttering ray of light traveled across the room to our receiver, which we built from largely off-the-shelf stuff: a photocell to convert varying intensities of light into varying intensities of electrical current, an amplifier, and a microphone to convert electrical current into sound. Finally, the original voice was reproduced at the other end. Looking back on this project decades later, I still regard the contraption as miraculous. Yet I knew exactly how it worked. I had put it together piece by piece. (In college, I also learned how photocells and microphones work.) As with my pendulums, here

was evidence that mechanism and cause underlay the workings of the world. There was no need to invoke magic or the supernatural or any nonmaterial essence to explain earthly phenomena. The physical world was miraculous all on its own.

At the same time I was forming these materialist views of the cosmos, I also observed some amazing spectacles. With my microscope, I discovered an entire world, invisible to the naked eye. In a thimbleful of water from a nearby pond, I saw tiny creatures wriggling and gliding about, shaped like ellipses with little waving hairs. Paramecia. I saw roundish blobs, pulsating with smaller blobs inside them. I saw other minuscule organisms, hundreds of times smaller than a grain of sand, gyrating, turning, throbbing, sporting about.

Our family took vacations near Kentucky Lake, about 175 miles northeast of Memphis, where I grew up. Many mornings, if I rose early, I could see a mist hanging low over the lake. Ambers and lavenders and mossy green hues would refract in the air for an hour, then melt away like some rare species of plant in bloom for only a few hours.

In college, I had my first look through a good telescope and saw the rings of Saturn. Anyone who hasn't seen them should. They are perfect circles. They are so perfect and pure that you think they couldn't be real. You think that nothing in nature could attain such perfection. And yet there they were, almost a billion miles away, austere, cold, and crisp, floating in silent perfection.

Understanding the material and scientific underpinnings of these spectacular phenomena hasn't diminished my awe and amazement one iota. So I don't believe in miracles, but I do believe in the miraculous. The miraculous abounds, and the material world and its laws are quite enough to explain it. And that too is miraculous.

THE MIRACULOUS
FROM THE MATERIAL

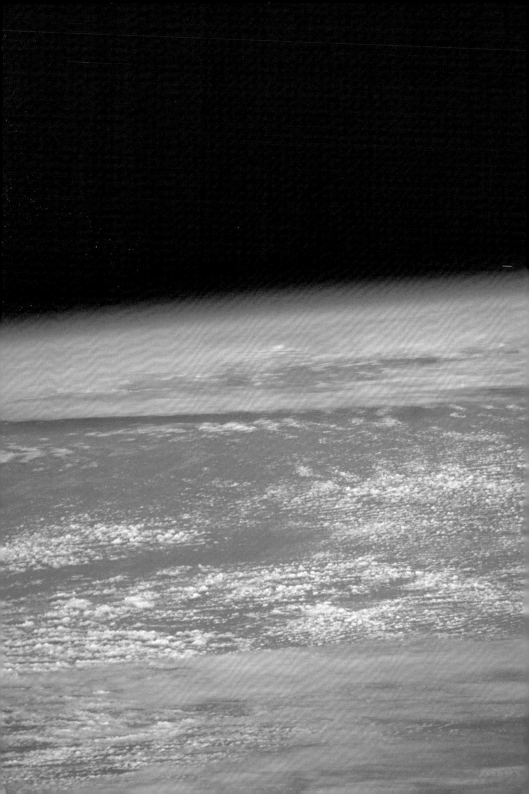

ATMOSPHERE

Many years ago, I had a conversation with former astronaut Jeffrey Hoffman, who made five trips aboard the space shuttle from the mid-1980s to the mid-1990s. What I will never forget was his description of the Earth as seen from space. He said that the atmosphere looked like a "thin, blue ribbon" encircling the planet. Exactly the same words were used by former astronaut Piers Sellers, in an interview in 2016: "You get up there, and the Earth is this huge ball. And when you look at the horizon, there's this tiny film of gas around it. It's just a thin, blue ribbon. It's the atmosphere. I mean, there's almost nothing there."

The U.S. satellite *Explorer 6* captured the first photograph of Earth from space, in 1959. But it was a black and white photo. Not until a couple of decades later did we technological creatures capture the first color photos of our planet, showing the blue atmosphere.

We take the air around us for granted, like night and day. But in fact, we wouldn't exist without it. There are other, less obvious roles played by our atmosphere. Its upper layers absorb harmful ultraviolet light from the Sun. Ultraviolet light can cause cancer, blindness, and other serious health problems. Our atmosphere also acts as a blanket, holding in the heat radiated by the ground and keeping us warm. Without an atmosphere, the temperature of the Earth would be far

below freezing, about 8 degrees Fahrenheit. One other unpleasant item: the oceans and all surface water would boil away without the pressure of the atmosphere.

But getting back to the thin, blue ribbon. Why is it blue? And why is it thin? The atmosphere is blue because blue wavelengths of light are scattered by the molecules of air to a greater degree than red wavelengths of light. As explained in the essay "Rainbows," sunlight consists of a range of colors that blend together to make white light. Each color corresponds to a different wavelength. (Light consists of traveling waves of energy, with troughs and crests, like waves in water. The distance between successive crests is called the wavelength.) The shorter wavelengths, toward the blue end of the spectrum, interact with air molecules more strongly than the longer wavelengths, toward the red end of the spectrum, and get scattered about from one molecule to the next, eventually moving in all directions. That's why we can see daylight even when not looking directly at the Sun.

While the atmosphere covers the entire Earth, when we photograph the Earth from space, we look through much more atmosphere in the direction of the edge of the Earth than in the vertical direction, straight down. Similarly, on a foggy day the fog appears much thicker when looking sideways, parallel to the ground, than when looking vertically up. Because of these simple geometrical effects, we see a blue ribbon encircling the Earth rather than a spherical shell surrounding it.

What determines the thickness of the atmosphere? Temperature, gravity, and the types of molecules. The molecules of Earth's atmosphere—oxygen, nitrogen, carbon dioxide, and water vapor—are zigzagging around, like all molecules in a gas. Their motions in the vertical direction can reach only so high before the Earth's gravity pulls them back, like balls thrown upward. The maximum height they can reach is determined by the strength of the Earth's gravity and by

their average speed, which in turn is determined by the temperature of the air. (The higher the temperature, the faster the average speed.) Given these factors, the maximum height of most of the air molecules on Earth is around 6 miles. That's the thickness of most of our atmosphere. Given that the Earth's diameter is nearly 8,000 miles, 6 miles of atmosphere is only a tiny sliver. No wonder the atmosphere appears like a thin ribbon from space. For comparison, most of the atmosphere of Venus is in a layer 10 miles thick, Mars 7 miles thick.

Our atmosphere was not always rich in the oxygen needed for our survival. The air of primitive Earth, billions of years ago, consisted mainly of nitrogen, water vapor, hydrogen sulfide, methane, and carbon dioxide. These were the gases released by the molten rock of primitive Earth. And, in fact, the first life-forms on the infant Earth, such as bacteria and other microorganisms, had to live on these gases. But as plants emerged through evolutionary process, they developed the chemical machinery of photosynthesis, which absorbs carbon dioxide and releases oxygen. The "era of oxygen" began about 2.5 billion years ago.

For hundreds of thousands of years, human beings had no idea what our planet looked like. Could fish imagine trees on dry land? Only very, very recently in our evolutionary history have we been able to see our home planet in its fullness. And only recently have we glimpsed the thin, blue ribbon of air that keeps us alive, a fragile shield between life and death. Every inhabitant of our planet should see this photograph.

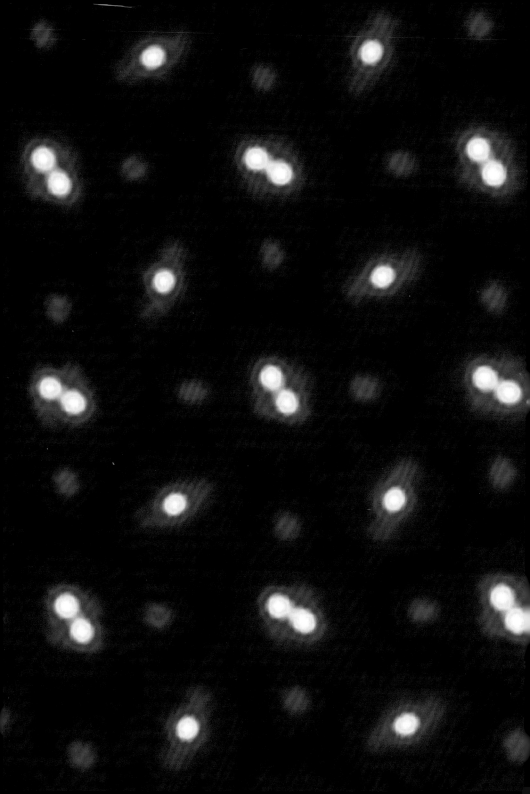

ATOMS

It seems probable to me that God in the beginning formed
matter in solid, massy, hard, impenetrable, moveable
particles . . . so hard as never to wear or break in pieces.

—Isaac Newton,
Optics (1704)

The idea of fundamental elements of nature can be found in all
cultures and eras. Thinkers in ancient India conceived of a system
of three elements for constructing the cosmos: fire, water, and earth.
Fire was associated with bone and speech, water with blood and urine,
earth with flesh and mind. Aristotle built the cosmos out of five
elements: earth, air, water, fire, and aether (for the heavenly bodies).
For the ancient Chinese, the fundamental elements were wood, fire,
metal, water, and earth. Evidently, we human beings are driven to
understand the universe in terms of a small number of fundamental
elements.

It may have been the ancient Greeks who first conceived of a tiniest
unit of matter, the atom or *atomos,* meaning "uncuttable." Atoms were
not only uncuttable. They were indestructible. Atoms protected us
from the whimsy of the gods, said Democritus (ca. 460 BC–370 BC)
and Lucretius (ca. 99 BC–54 BC), because atoms could not be created

or destroyed. Even the gods had to obey atoms. In his masterpiece *De rerum natura,* Lucretius called these tiniest, indestructible elements of matter *rerum primordia,* "the first beginnings of things."

Of course, the atoms of Democritus and Lucretius, and even Newton, were all speculations. There was absolutely no evidence for a tiny, indestructible element of matter, not to mention that it would be unseeable by the human eye even if such a thing existed.

One of the first people to provide real evidence for the existence of atoms was the British chemist John Dalton (1766–1844). In 1808, he published a paper showing that different chemicals combine in definite proportions, suggesting that there are some small, indivisible building blocks that compose them. The proportions can be determined by measuring volume and weight. For example, Dalton could measure the amount of carbon and amount of oxygen that combined to form carbon monoxide (each molecule of which we now know is made of one atom of oxygen and one atom of carbon). He could then combine the same amount of carbon with a second amount of oxygen to form carbon dioxide (two atoms of oxygen for each atom of carbon). He found that the second amount of oxygen, making carbon dioxide, was exactly twice the amount making carbon monoxide, suggesting that oxygen and carbon occur in some basic units in forming molecules.

Austrian physicist Johann Josef Loschmidt (1821–1895) was the first to estimate the physical size of atoms, in 1865. Actually, Loschmidt measured the size of molecules of air, which are not much larger than single atoms. He did this by comparing a volume of liquified air with the same quantity of air in gaseous form and using known results of how far a molecule of air can travel before striking another molecule of air. From an analysis of Loschmidt's work, it could be concluded that an atom was about one-hundredth of a millionth of a centimeter, or about 0.00000001 centimeters. (A centimeter is about 0.4 inches.)

In other words, if you put a row of atoms end to end on a table, it would take about 200 million to stretch an inch.

But how could you ever see anything so small? How could you ever build an instrument that could see anything so small?

Only a few years ago, in 2021, a group of scientists led by David A. Muller of Cornell University obtained the first high-resolution photograph of atoms. They did so by beaming high-energy electrons at a crystal and then measuring how the electrons were scattered by the atoms in the crystal. Quantum physics has shown that all particles behave partly like water waves. They don't occupy a single point in space, but instead have a spread. To probe very small things, you need very short waves, just as a watchmaker needs tiny tools to probe the tiny mechanism of a watch. Furthermore, a basic principle of physics is that the higher energy the electrons, the shorter their wavelength. In this case, the electrons are the tools. That's why Muller et al. had to beam very high energy electrons at the crystal to reveal its atomic structure. By using a computer to record how the scattered electron waves overlapped with one another and scanning the crystal at many different layers, the computer could reconstruct a 3D picture of the atoms. The technique is called electron ptychography. (*Ptych* is the Greek word for "fold." The different scattered electron waves are folded into one another.)

The photo at the beginning of this chapter was taken by Muller's group and may be the limit of how clearly we can see atoms, because atoms are always jiggling a bit—even atoms in solid materials—causing an unavoidable blurring of any photograph.

Since the late nineteenth century, we have known that even atoms are made of smaller parts. Electrons are smaller than atoms, and the protons and neutrons in an atom's nucleus are smaller. And each proton and neutron is made of even smaller particles, called quarks. How

far can we go in our search for the smallest elements of the physical world? Can this endeavor go on indefinitely, to the infinitely small?

Perhaps surprisingly, no. At an unimaginably small size called the Planck scale, at 0.00000000000000000000000000000001 centimeters, quantum physics and gravitational physics combine to eliminate time and space as we know it. At the Planck scale, space churns like a boiling cauldron and time flits around, sometimes going forward and sometimes backward. With time and space behaving so strangely, particles and waves, space and time, and even reality as we know it cease to exist. None of the machines that we have now or can now envision could explore nature at so small a scale, fantastically removed from our world of tables and chairs and even the world of the atom. Yet it is a tribute to the human mind that we can conceive of such an end point of nature, and quantify it.

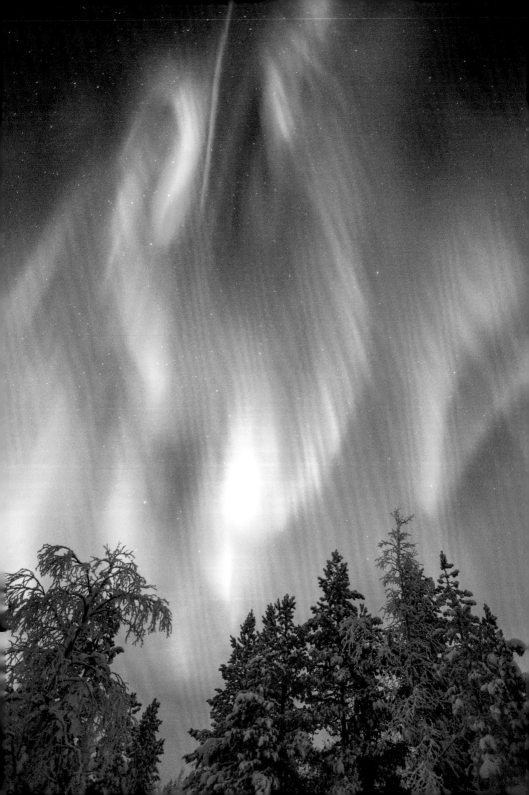

AURORAE

O'er all the widespread northern skies,
How glows and waves that heavenly light,
Where dome, and arch, and column rise
Magnificently bright!

—Stephen Greenleaf Bulfinch,
"The Aurora Borealis" (1834)

The oldest written records of the aurora borealis may be some symbols on three Assyrian and Babylonian cuneiform tablets, dating to about 680 BC to 650 BC. The Indigenous American Cree believed that the aurorae, also known as the northern lights, were dead spirits who lived in the sky, trying to send messages to their living families. The Algonquin people regarded the aurora borealis as a fire made by their creator, Nanahbozho, and was a message assuring the safety of his people. Inuit tribes believed that the northern lights were dead human spirits playing ball with a walrus skull. Elsewhere in the ancient world, the Vikings thought the lights were a reflection off the armor of the Valkyries, the supernatural maidens who carried warriors into the afterlife.

Even today, with our knowledge of modern science, witnessing the aurora borealis is a surreal experience, like beholding an eclipse.

We are swept away from our familiar lives of office jobs and dentist appointments and transported to a cosmic domain. As the greenish-blue lights swim and shimmer high in the sky, we are reminded that we are tiny creatures in a vast universe. Gigantic things are going on out there in space while we sit in our warm houses. And for a few moments at least, looking up at the sky, we are part of it.

The aurora borealis is produced by the emissions of oxygen and nitrogen molecules in the upper atmosphere of the Earth, energized by electrons streaming from the Sun. As discussed in the essay "Shooting Stars," each different type of atom or molecule produces a different color of light when its outer electrons change energy levels. Oxygen atoms produce green light. Molecules of dinitrogen (two nitrogen atoms bonded together) produce blue and purple light. As discussed in the essay "Galaxies," the Sun and all stars are hot spheres of gas. The surface of the Sun has a temperature of about 10,000 degrees Fahrenheit. Our nearest star also has a strong magnetic field. The high temperatures and the Sun's magnetic field propel electrically charged subatomic particles, electrons and protons, outward from the solar surface, in what is called a solar wind. When this "wind" reaches the Earth, it has the unimaginable speed of about 250 miles per second. There, the particles are trapped by the Earth's own magnetic field. They spiral around and follow those fields toward the poles. When the charged particles reach the Earth's atmosphere, they collide with the oxygen atoms and nitrogen molecules in the air. Each atom receives energy from the collisions and then releases that energy in the form of light. That's the aurora borealis.

The unusual folds and curtains of the aurorae result from the precise positions of charged particles from the Sun, which in turn are affected by the shape of the Earth's magnetic field. In fact, you can reproduce that shape if you put a bar magnet under a sheet of paper

and sprinkle some iron filings on it. You will see the curved pattern of the magnetic field. The Earth's magnetic field, although invisible, has a similar pattern.

It was the Italian physicist Galileo (1564–1642) who coined the name "aurora borealis" in 1619, combining Aurora, the Roman goddess of the dawn, and Boreas, the Greek god of the north wind.

The most spectacular aurorae in recent history occurred from August 28 to September 2, 1859, the result of an enormous solar storm, expelling an extremely intense solar wind toward Earth. The resulting aurorae were so brilliant that they were reported in ship's logs and newspapers throughout the world. According to an article in London's *Morning Post* titled "Luminosity and Electricity in the Sky," "The heavens were brilliantly illuminated . . . by a mass of white rays or streaks, completely suffused with a vapor of a pink or dark roseate hue, through which brightly shone the stars, presenting a most beautiful appearance. . . . The phenomenon . . . was sufficiently luminous . . . to permit the reading of print letters ⅛th of an inch in size."

BIOLUMINESCENCE

Some years ago I was returning to my island house in Maine, under a dark night sky, and I noticed that the wake of the boat was glowing. As far as I could tell, it was bluish in color. That was my first experience with bioluminescence. Later, I discovered that I could create that same oceanic glow simply by waving a stick or paddle in the water. Bioluminescence—the glow produced by fireflies, algae, and a few other organisms—is a beautiful and eerie phenomenon. It's the natural light of our terrestrial world. No human-made candles or flashlights or batteries needed.

In December 1833, writing in his journal aboard the *Beagle*, Darwin described bioluminescence (which he called "phosphorescence of the sea"):

While sailing in these latitudes on one very dark night, the sea presented a wonderful and most beautiful spectacle. There was a fresh breeze, and every part of the surface, which during the day is seen as foam, now glowed with a pale light. The vessel drove before her bows two billows of liquid phosphorus, and in her wake she was followed by a milky train.

One of the first known descriptions of the phenomenon was by Aristotle (384 BC–322 BC) in his book *De anima* (*On the Soul*),

where he writes that "some objects of sight which in light are invisible, in darkness stimulate the sense; that is things that appear fiery or shining."

As described in the essay "Fireflies," bioluminescence is caused by a chemical reaction. An organic molecule called luciferin produces energy when combined with oxygen. That energy is temporarily stored in another molecule called adenosine triphosphate, which is found in all living organisms. Essentially, the electrons in the atoms of adenosine triphosphate and the oxidized luciferin move to lower energy levels and release that energy differential in the form of light. In a similar manner, wood reacting with oxygen (in a fire) produces light. But unlike fire, which produces heat as well as light, the chemical reactions in bioluminescence produce a "cold fire." Light but no heat. The process is extremely efficient and converts nearly 100 percent of the chemical energy into light. Bioluminescence can come in a range of colors, depending on the type of luciferin. Squids, for example, are able to produce multiple colors.

The bioluminescence that comes from stirring up the ocean is produced mostly by algae and plankton. Fascinating members of this group are the microscopic, single-celled organisms known as dinoflagellates. Like plants, they take in carbon dioxide and release oxygen. Dinoflagellates are at the bottom of the oceanic food chain. They're eaten by copepods, miniature versions of shrimp. Bigger fish eat copepods, and so on, until we're up to the great white shark. Dinoflagellates swim about by waving tiny hairs, the flagella or cilia. (See the essay "Paramecia" for more on cilia.)

Why do these organisms produce light when disturbed? Such activity costs energy, and they wouldn't expend the energy without a good reason. In evolutionary terms, there must be some survival benefit to bioluminescence. Biologists believe that bioluminescence, like most

all distinctive traits, evolved to attract mates, defend against predators, and aid in the hunt for food.

Recent research by biologist Andrew Prevett of the University of Gothenburg, Sweden, and his colleagues suggests several survival benefits of bioluminescence for dinoflagellates in particular—all to protect the organisms against their major predators, the copepods. First, the flash acts as a warning and notifies the preying copepods that the dinoflagellates are toxic. (Indeed, they contain saxitoxin and its derivatives.) The association of visual warning signals with toxicity and their use as a survival strategy is found in a number of other animals, such as poison dart frogs. As discussed in other essays, if your predator doesn't identify you for what you are, then it may eat you before it realizes you are poisonous. Second, the flash can startle would-be assassins, allowing time for the dinoflagellate to escape. Squids and certain other fish use the same tactic. For dinoflagellates, the flash also serves as an advertisement to larger fish, who then swim to the feast and dine on the copepods, while the dinoflagellates move to safer territory.

It's astonishing that a single-celled organism can evolve such effective defense mechanisms and strategies. That development, acting through the long and dark hallways of evolution, clearly shows that natural selection is a purely mechanical process. No intelligence is required. No brain is required. All that's needed are random genetic mutations, many caused by copying errors in gene duplication. A small fraction of those mutations produce traits that have survival benefit. By and large, organisms without those beneficial traits die off before reproducing when faced with a difficult environment. Organisms with those traits live to pass on their modified genes. It's a simple but profound idea. And it's all mindless, just as the beautiful phenomenon of bioluminescence emerges without plan or design.

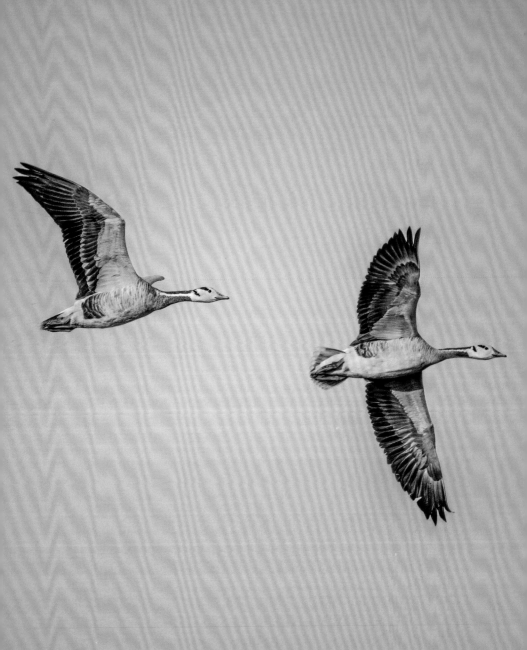

BIRDS

If happy little bluebirds fly beyond the rainbow,
Why oh why can't I?

> —"Over the Rainbow," song by Harold Arlen with
> lyrics by Yip Harburg, first sung by Judy Garland,
> MGM soundstages, October 7, 1938

We humans have always been fascinated by the flight of birds. And
dreamed of flying ourselves. Leonardo da Vinci designed something
called an ornithopter, a platform with wings that a human would
power by flapping his or her arms.

As Leonardo wrote in his notebooks,

Remember that your flying machine must imitate no other than
the bat. . . . An object offers as much resistance to the air as the

air does to the object. You may see that the beating of its wings against the air supports a heavy eagle in the highest and rarest atmosphere. . . . A man with wings large enough and duly connected might learn to overcome the resistance of the air, and by conquering it, succeed in subjugating it and rising above it.

Leonardo's craft, shown above, was never built. And even if it had been built, it would not have worked. Human-powered flight would have to wait 475 years, for modern materials and technology.

The first human-powered flight occurred on November 9, 1961. The craft, built by a group of aeronautical engineering students, was made of balsa, plywood, and aluminum, covered with nylon. The pilot, Derek Piggot, powered the propeller with bicycle pedals. But he was able to stay in the air only a minute or so.

How do birds do it, almost miraculously violating the laws of gravity? Clearly, the bird must create an upward force to counter its weight. That force is created by a net upward air pressure, which in turn is created by the bird's forward motion and the shape of its wings. The topside of an avian wing is curved, while the bottom side is rather flat. This difference in shape, together with the angle and some smaller adjustments of the wing, cause the air to flow over the top of the wing at higher speed than on the bottom. The higher speed on top reduces the air pressure above the wing compared to the air pressure below the wing. With more pressure pushing up from below than pressure pushing down from above, the wing gets an upward lift.

And why does a higher speed of air over the wing produce a lower pressure? Air consists of little molecules that push against whatever they strike, causing pressure. Molecules of air are constantly whizzing about in all directions. If no energy is added, the total speed of the molecules must be constant, by the law of the conservation of energy.

But that speed is composed of two parts: a horizontal speed, parallel to the wing, and a vertical speed, perpendicular to the wing. Increase the horizontal speed of air molecules above the wing, and the vertical speed of those molecules must decrease. Lower speed of molecules striking the wing from above means less pressure, or less push. The molecules on the bottom of the wing, moving slower in the horizontal direction but faster in the vertical direction (with greater upward pressure), lift the wing upward.

The lift is greater the larger the wing area and the faster the speed of air past the wing. There's a convenient trade-off here. The necessary lift force to counterbalance the bird's weight can be had with less wing area if the animal increases its forward speed, and vice versa. Birds capitalize on this option according to their individual needs. The great blue heron, for example, has long, slender legs for wading and must fly slowly so as not to break them on landing. Consequently, herons have relatively large wingspan. Pheasants, on the other hand, maneuver in underbrush and would find large wings cumbersome. To remain airborne with their relatively short and stubby wings, pheasants must fly fast. The birds themselves had no vote in their design. They simply go about their business, unconsciously following the marching orders of their DNA, like the rest of us.

Since the upward lift on a bird in flight results from molecules of air striking against the underside of the wing, a bird needs air to fly. No air, no lift force. Birds couldn't fly on the Moon. (Under the Moon's reduced gravity, however, creatures could jump six times as high as on Earth, which might make a happy substitute.)

The upward lift also requires air to flow past the wings. How does the bird manage that? Of course, once it's moving forward, air is flowing past its wings. How a bird propels itself forward, without propellers, is not obvious. The mystery was clarified in the early nineteenth century

by English engineer and aviator Sir George Cayley (1773–1857), father of the modern airplane. Birds do in fact have propellers, in the form of specially designed feathers in the outer halves of their wings. These feathers, called primaries, change their shape and position during a wingbeat. Forward thrust is obtained by pushing air backward with each flap. In a similar manner, we are able to move forward in a swimming pool by vigorously moving our arms backward against the water. (According to Isaac Newton's third law of motion, every action has an equal and opposite reaction.) Air moving backward pushes the bird forward, causing more air to flow over its wings and producing lift.

An interesting feature of birds flying in groups is the familiar V formation. Studies have shown that each bird after the leader in such a formation saves 20 percent to 30 percent of its calories—the reason being that each of the follower birds gets to take advantage of the uplifting pockets of air produced by the bird in front of it. The lead bird, at the point of the V, is doing most of the work. For this reason, birds take turns being the lead.

Finally, why don't we see any birds aloft the size of elephants? As you scale up the size of a bird or any material thing, unless you drastically change its shape, its weight increases faster than its area. Weight is proportional to volume, or length times length times length, while area is proportional to length times length. Double the length, and the weight is eight times larger, while the area is only four times larger. For example, if you have a cube of 1 inch on a side, its volume is 1 cubic inch, while its total area is 6 (sides) × 1 square inch, or 6 square inches. If you double the side of the cube to 2 inches, its volume goes up to 8 cubic inches, or 800 percent (with a similar increase in weight), while its area goes up to 24 square inches, or 400 percent. Since the lift force is proportional to the wing area while the opposing weight force is proportional to the bird's volume, as you continue scaling up,

eventually you reach a point where the bird's wing area is not enough to keep it aloft. Although birds have been experimenting with flight for 100 million years, the heaviest true flying bird, the great bustard, rarely exceeds 42 pounds. The larger gliding birds, such as vultures, are lifted by rising hot air columns and don't carry their full weight.

What about airplanes? They're much heavier and larger than birds but manage to stay airborne. How do they do it? The explanation is that, pound for pound, internal combustion engines are a couple hundred times more powerful than the muscles of biological creatures. The propeller on a prop airplane or the turbine on a jet can cause the air to rush past the wings at a far greater speed than the flesh-and-blood primary wings of a bird. Thus a Boeing 747, weighing over 400,000 pounds, can fly in the air. But not nearly so gracefully as a bird.

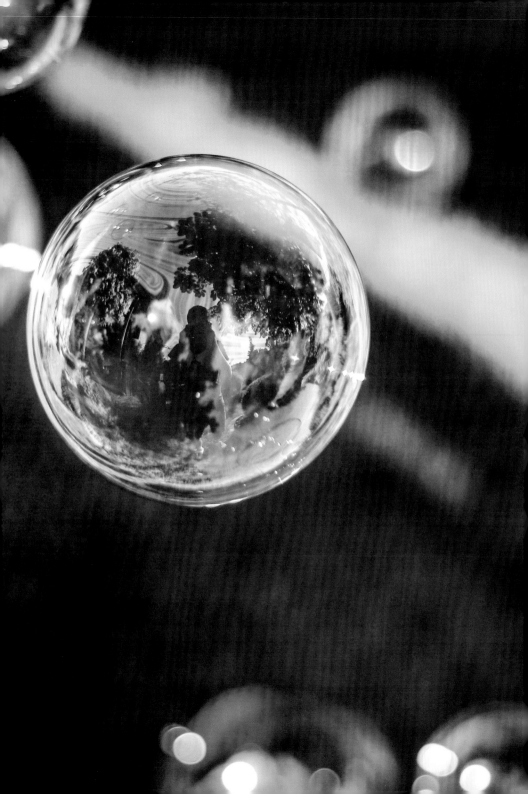

BUBBLES

A favorite activity of my children was to blow soap bubbles and then watch them as they floated about in the air—delicate, shimmering, drifting this way and that when caught by a wandering breeze. I was as mesmerized as my kids looking at the perfect spheres, practically weightless, transforming an ordinary scene into a fairyland. Somehow, watching soap bubbles slipping so easily through the air makes you feel lighter.

One of the most amazing features of soap bubbles is their perfectly spherical shape. How could anything in nature be so perfect? Physics and mathematics.

First, the material of the bubble. A soap bubble is made of a thin layer of soap sandwiched between two thin layers of water—surrounding a spherical volume of air. When you blow a soap bubble, you force air into the soapy water. The soap and water molecules link together and surround the air, forming the bubble.

Why are soap bubbles spherical? To answer that question, we must consider energy. A molecule that is attractively bonded to other molecules has lower energy than an unbonded molecule, because you must *add* energy to break the bonds apart and free the molecule. Similarly, you must use force to pull apart two objects glued together. The more bonds, the more energy that must be added to break the bonds, hence

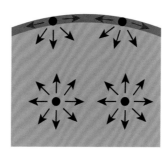

the lower the energy of the heavily bonded molecule. Conversely, the fewer bonds, the higher the energy.

The figure above shows a small section of the skin of a soap bubble. Molecular bonds are represented by arrows. (The red arrows indicate the molecular bonds at the outer surface of the bubble.) As shown in the figure, a molecule at the surface of the bubble has fewer bonds than a molecule in the interior because there are no nearby molecules exterior to it (above it in the diagram). Thus, a surface molecule has *higher* energy than a molecule in the interior. You might call this extra energy relative to molecules in the interior. The total extra energy of these surface molecules is proportional to the number of them, which, in turn, is proportional to the total surface area of the bubble.

A very important principle in physics is that systems evolve to a condition of the lowest possible energy available to them. That's because systems with lower energy are more stable. A marble on the floor has lower energy than a marble on a tabletop because you must expend energy to lift it up to the table. The marble on the table, with higher energy, is unstable; it will fall to the floor with the slightest disturbance. The needle of a compass orients itself to align with the Earth's magnetic field because that is the condition of lowest energy.

Now let's apply this concept of minimum energy to the soap bubble. Since the extra energy of the bubble is proportional to its surface area, the bubble will evolve in a way to minimize that area. But it cannot

change the volume of air it encloses, because that air is trapped within the bubble. So the question becomes: What is the shape of an object that minimizes its area for a fixed volume? The answer: a sphere. For example, a sphere has about a 19.4 percent smaller area than a cube with the same volume—indeed, a smaller area than any object with the same volume. Caught between physics and mathematics, soap bubbles have no choice but to be spherical in shape.

The "minimum energy principle" shows up in many places. Nature usually works to accomplish its tasks with the minimum expenditure of energy. A fascinating example is bees. Anyone who has seen a honeycomb knows that it is constructed of hexagonal cells. But why hexagons?

More than 2,000 years ago, in 36 BC, the Roman scholar Marcus Terentius Varro conjectured that the hexagonal grid is the unique geometrical shape that divides a surface into equal cells of fixed area with *the smallest total perimeter.* And the smallest total perimeter, or smallest total length of sides, means the smallest amount of wax needed by the bees to construct their honeycomb. For every ounce of wax, a bee must consume about eight ounces of honey. That's a lot of work, requiring tiresome visits to dozens of flowers and much flapping of wings. The hexagon minimizes the effort and expense of energy. But Varro had made only a hypothesis. Astoundingly, Varro's conjecture, known by mathematicians as the honeycomb conjecture, was proven only recently, in 1999, by the American mathematician Thomas Hales. The bees knew it was true all along.

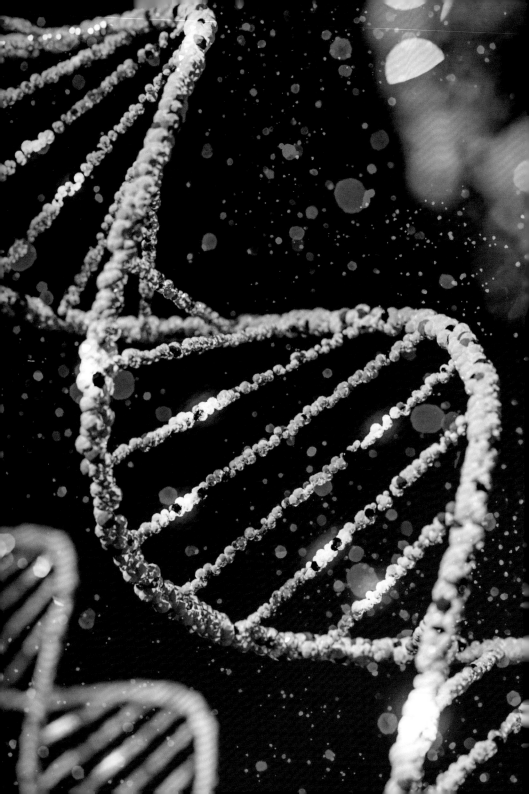

DNA

In one of the episodes of *Star Trek: the Next Generation,* Commander Data fractures a part of himself, a hand as I remember, and stares at the bare tangle of wires and computer chips protruding from his wrist. Although Data is a machine, we have come to regard him as human. And thus something disturbs us about this scene, not so much because Data is hurt, but because he sees inside his own mechanism. The secret of his being hangs in the open air. How can a creature know itself in this way, gaze into its own inner workings? Conceivably, such a creature could build itself—a maker that makes itself.

In the last seventy-five years, we human beings have discovered much of our own mechanism—in the chemical structure of a molecule called DNA. Most molecules have a fixed structure. By contrast, the DNA molecule has pieces that vary, and the particular variations and arrangements of those pieces, like the order of letters that form words, chemically spell out the instructions for how to make a *particular* human being or any living organism. Louis Armstrong's DNA is different from Aretha Franklin's.

Perhaps the most striking architectural feature of the DNA molecule is its helical structure. Why does it have this spiral form? (See the essay "Spiral Plants" for a more extended discussion of spirals in nature.) A DNA molecule is made out of three parts: sugar, phosphates, and

bases. The sugars and phosphates make up the "legs" of the DNA molecule. The bases are the "rungs" of the spiral "ladder" and carry all the information. The twisting form of the molecule results from the ability or inability of these three parts to bond with water molecules, which are ubiquitous in all cells.

The sugars and phosphates easily bond with water molecules. The bases (adenine, cytosine, guanine, and thymine) don't. In fact, the structure of these four bases and the structure of the water molecule are such that they repel each other—due to the repulsive electrical force of electrons in one molecule near electrons in another. (Like charges repel.) Thus, the bases are pushed as far away from the water molecules as possible. They take up positions within the sugar-phosphate legs, partially shielding them from the water molecules. There, the bases form the rungs of the DNA ladder.

Now comes the twisting. Even with the bases inside the DNA ladder, they still come into contact with some amount of water, which fills the empty spaces between rungs of the ladder. This space is reduced if the ladder is twisted. You can demonstrate this geometrical effect yourself. If you take a piece of string, measure its length along a ruler, and then begin twisting the string at each end, you'll find that its length decreases. In a similar manner, the length of the sugar-phosphorous legs of the DNA ladder is reduced with a twist, which in turn brings the steps of the ladder closer together and reduces the amount of water filling those empty spaces. That's why the molecule twists. However, as the twisting continues and the bases get closer, they begin repelling one another, again due to electrical forces. So the molecule doesn't twist indefinitely. The two kinds of repulsive forces—the first between the bases and the water molecules, and the second between the bases and other parts of the DNA molecule—are minimized with a partial twist.

Alternatively, we can consider the minimum energy principle: systems take the configuration that minimizes their total energy (see the essay "Bubbles"). The precise amount of twist, or pitch angle, that minimizes the total energy of the DNA molecule is 36 degrees.

The structure of the DNA molecule, including its helical shape, was discovered in 1952 by Rosalind Franklin, James Watson, and Francis Crick.

The excitement of their discovery, surely one of the most important in several centuries of science, can be felt in this account by Watson:

Then the even more important cat was let out of the bag: since the middle of the summer Rosy [Rosalind Franklin] had had evidence for a new three-dimensional form of DNA. It occurred when the DNA molecules were surrounded by a large amount of water. When I asked what the pattern was like, Maurice [Maurice Wilkins] went into the adjacent room to pick up a print [X-ray picture] of the new form they called the "B" structure. The instant I saw the picture my mouth fell open and my pulse began to race . . . the black cross of reflections which dominated the picture could only arise from a helical structure.

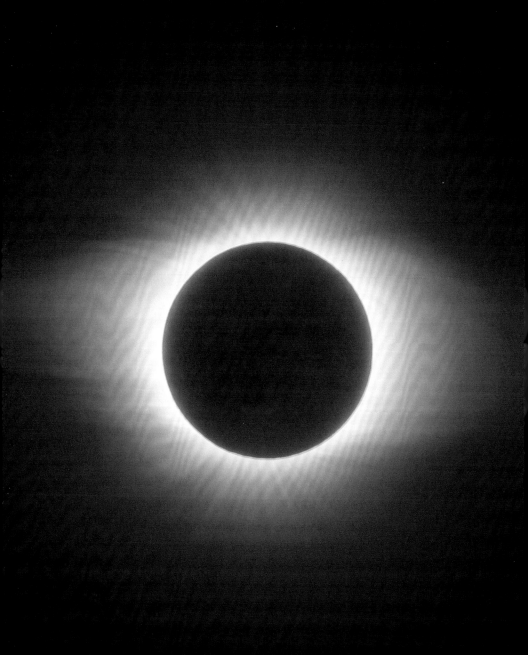

ECLIPSES

The earliest known recorded eclipse observation can be found on a cuneiform clay tablet discovered in the Syrian city of Ugarit. Cuneiform, consisting of wedge-like symbols, is considered the oldest written human language. It was used by the Sumerians as early as 3500 BC. Only in the nineteenth century was cuneiform deciphered. The Ugarit tablet describes a total solar eclipse that occurred on March 5, 1223 BC: "On the day of the new moon, in the month of Hiyar, the Sun was put to shame, and went down in the daytime, with Mars in attendance."

The ancient Chinese believed that solar eclipses happen when a cosmic dragon devours the Sun. To frighten the dragon away, the Chinese banged drums and pots. According to ancient Egyptian myth, a solar eclipse takes place when the giant serpent Apep attacks the boat of the Sun god Ra. (See the essay "Sunsets.")

With a rudimentary knowledge of astronomy, eclipses are one of the easiest natural phenomena to understand, although they were frightening for most of human history. Eclipses occur when the Sun, Earth, and Moon are lined up. A solar eclipse happens when the Moon passes in front of the Sun and blocks out some or all of its light. A lunar eclipse is caused when the Earth passes between the Sun and the Moon. In a lunar eclipse, we see the shadow of the Earth on the Moon.

As shown in the photograph here, that shadow is curved. Aristotle used that fact as one of his proofs that the Earth is round.

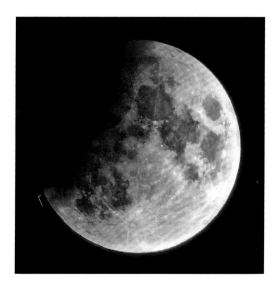

The maximum duration of a total solar eclipse, when the Sun is completely blocked by the Moon, is about 7.5 minutes. Many factors determine this duration, including the sizes and distances of the Moon and Sun, and the rotation speed of the Earth. That the Earth rotates on its axis was first proposed by the ancient Greek astronomer Aristarchus of Samos (310 BC–230 BC), but his theory was lost for centuries until given more evidence by the Polish astronomer Nicolaus Copernicus (1473–1543). Before Copernicus, most people believed that the Earth was motionless in space and that the heavens revolved about it.

It's a bizarre accident of nature that the Moon almost exactly covers the Sun during a solar eclipse, the reason being that the disks of the Moon and Sun are almost exactly the same angular width in the sky

as seen from the Earth, about one-half a degree (or ¹⁄₁₈₀ the angular distance from the horizon to a point directly overhead, 90 degrees). Which in turn is a consequence of the fact that the diameter of the Sun divided by its distance from us is almost the same as the diameter of the Moon divided by its distance, about 0.01. This fact is a total accident. If the Moon were smaller or farther away, solar eclipses would never be total, and they would happen less frequently. Likewise, if the Moon were larger or closer, total solar eclipses would last longer and occur more frequently. These alternative situations occur for other planets and their moons in our solar system.

Like many Americans, I watched the solar eclipse of August 2017. My daughter and son-in-law and their two children were visiting my wife and me in coastal Maine, not the perfect location but a 58 percent eclipse according to the estimates. A couple of days before the event, we realized that we didn't have the proper equipment, so we began calling around to procure eclipse sunglasses. All the nearby stores were completely sold out. Eventually, my wife located a tiny library in a town called China, Maine, about an hour and a half drive away, that had a good supply.

Meanwhile, our four-year-old granddaughter got wind that something important was in the works and asked me to explain eclipses. I took out several pieces of fruit, one being the Earth, one the Moon, and one the Sun, and put them in front of her in an arrangement such that the fruit Moon obscured the fruit Sun. "Can you show me that on the computer?" she asked.

During the eclipse, as the light dimmed, the animals around us began behaving strangely. The birds' squawking didn't seem normal. The squirrels scampered in unnatural ways—or at least it seemed so to us. The monarch butterflies hovering about the chives in our garden

swooped and fluttered as if in a trance. After a half hour of the eclipse, we'd had enough. We put down our sunglasses and got on with the rest of our day.

But something profound had happened to us. For a moment, we were aware of ourselves in the universe. We were aware of the cosmic nature of things, of the Moon as an enormous round ball orbiting the Earth, and the Earth as another ball orbiting the Sun and spinning about on its axis. And the immensity of space. Spectacular things are occurring out there, whether we notice or not.

FALL FOLIAGE

Sing a song of seasons!
　　Something bright in all!
Flowers in the summer,
　　Fires in the fall!

<div align="right">

—Robert Louis Stevenson,
"Autumn Fires" (1885)

</div>

Although I grew up in the South, I've spent the last half century in New England. Here, I've been treated to the beautiful "autumn fires" every cycle of the seasons. Some years, my wife and I will drive out from the Boston area to Western Massachusetts, where the fall foliage is even more beautiful. The splashy blend of yellows and reds and oranges in October often look not so much like a forest on fire as a painting by Jackson Pollock. A living Jackson Pollock on the largest possible canvas. Nature is not only a creator and a mathematician. She is also an artist. And Nature's gallery is the infinite outdoors, the fields and mountains and forests and streams. The fall foliage is among her most spectacular displays.

What makes such striking colors? Actually, it was a large asteroid that collided with the Earth 4 billion years ago. But we'll get to that part of the story later.

Here, as in so many other phenomena in nature, the appearance of one thing is caused by the suppression of another. In the case of forests and their leaves, the yellow, red, and orange pigments are always present, in the form of chemical compounds called carotenoids and anthocyanins. Carotenoids help with photosynthesis, the process of converting sunlight to energy, and anthocyanins protect leaves from an excess of sunlight. The carotenoids are responsible for the orange and yellow colors of such things as carrots, corn, bananas, and flamingos. (See the essay "Scarlet Ibises.") Anthocyanin gives the red color to red apples, cherries, and strawberries. During most of the year, these colors are masked by the dominating green produced by chlorophyll.

Found in all plants, chlorophyll is a chemical that produces the energy needed for life and growth. Sunlight is the ultimate source of that energy. In photosynthesis, leaves use the energy of sunlight to convert carbon dioxide (composed of carbon and oxygen) and water (composed of hydrogen and oxygen) into sugar (made of carbon, oxygen, and hydrogen). Sugar, in turn, stores energy in its chemical bonds and can release that energy for the various metabolic needs of plants and animals.

Chlorophyll is green because its molecular structure is such that it absorbs light in all wavelengths except those corresponding to the color green. (See the essay "Rainbows" for a discussion of light as a composition of energy waves of different wavelengths and the relation between color and wavelength.) The green wavelengths, not being absorbed, are instead reflected. In fact, that's the origin of the color of all things. What we perceive and describe as color are the wavelengths of light *not* absorbed by a particular object and its internal molecular structures.

During the growing season, chlorophyll molecules are constantly being assembled and then disassembled. But in the autumn, sunlight

is less plentiful and the growth rate of most living things decreases. That slowdown is accompanied by less chlorophyll production. With the dominating green of chlorophyll held at bay, the reds, yellows, and oranges of carotenoids and anthocyanins can come out of hiding. When winter arrives, with even less sunlight and cold temperatures, growth comes to a halt, and many trees shed their leaves altogether to conserve energy. Walking through a forest in the late fall, one can hear the tiny *tsk tsk* of falling leaves as they break from their stems and kiss the ground.

Oneida Indigenous Americans tell a tale called "Chasing the Bear" about the origins of fall foliage. The story goes that in ancient times, three hunters set out to track a bear at first snowfall. After almost a year of arduous travel across the entire Earth, never stopping to eat or sleep, the hunters finally catch up with the bear and slay it. They lay the bear on some oak and sumac branches. Its blood stains the leaves red, explaining why the leaves of trees turn red in the fall.

I'll end with a scientific story about the origins of fall colors. Because all growing things depend on sunlight and temperature, they have life cycles following the seasons (in latitudes where there are seasons). Our seasons, in turn, are caused by the tilt of the Earth's axis—that is, the angle between the rotation axis of the Earth and a line perpendicular to the plane of the Earth's orbit about the Sun, as shown in the diagram.

If the Earth's rotation axis were parallel to that perpendicular, each point on the Earth would receive the same amount of sunlight throughout the year. (This analysis assumes that the orbit of the Earth is nearly circular, so that it remains nearly the same distance from the Sun throughout the year, an assumption true not only for Earth but for all planets in our solar system.) Because of the tilt of the Earth as our planet moves in its annual orbit about the Sun, northern latitudes receive more sunlight when the North Pole points toward the Sun (summer) and less sunlight when it points away (winter). No tilt, no seasons. No seasons, no fall foliage.

And what caused the tilt? It was a cosmic accident billions of years ago, during the formation of the solar system. Scientists have much evidence that a solar system is formed by a rotating cloud of gas and dust. Due to gravity, the gas and dust condense into stars, planets, and moons. On the whole, the rotation of the original cloud of gas and dust is embodied in the orbital rotation and spins of the planets. Indeed, all the planets in our solar system orbit the Sun in the same direction. However, some small fraction of the original material had random motions not following the overall pattern of rotation. Collisions between that renegade material and the nascent planets tilted them to varying degrees. While Earth has a tilt of 23.5 degrees, Uranus has a tilt of 82 degrees, and Saturn a tilt of 26.7 degrees. Mercury is the only planet in our solar system with almost no tilt. As a result, it has no seasons. In sum, one can say that our gorgeous fall foliage originated in a random cosmic collision during the infancy of our solar system. Accidents can sometimes lead to great beauty.

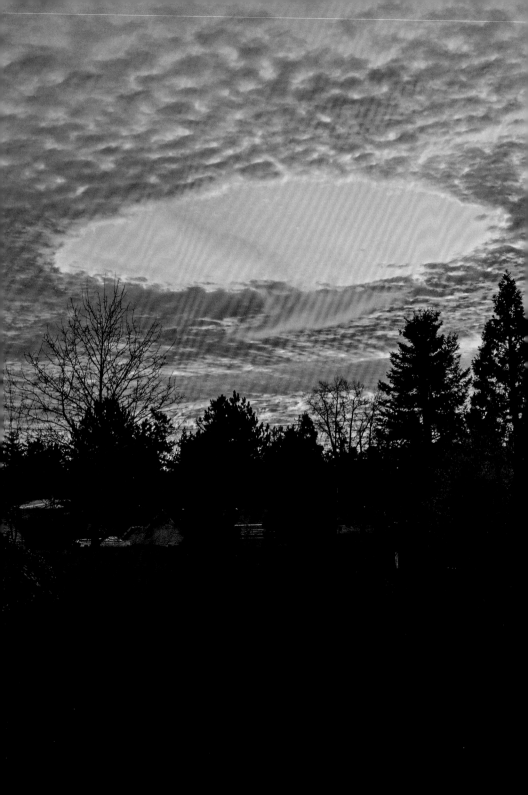

FALLSTREAK HOLES

Many phenomena of nature are beautiful. But some are bizarre as well—those that are rare, unfamiliar, and highly dramatic. Fallstreak holes fall into that category. In fact, some witnesses have claimed that fallstreak holes, also called hole punch clouds, are not natural phenomena at all, but UFOs invading Earth. When a fallstreak hole appeared over Victoria, Australia, on November 3, 2014, a newspaper headline said that residents were "stunned and confused." One man reported that "we just looked up and there was this thing that looked like something out of *Independence Day.*" (*Independence Day* is a sci-fi film in which an enormous extraterrestrial spaceship comes to Earth and deploys gigantic flying saucers, which hover over major cities.)

Personally, I've never seen a fallstreak hole, but I've seen lots of photos, and they are pretty weird. They are also rare, requiring very particular atmospheric conditions and geographical locations.

Despite some popular belief, the probability that any of these events and sightings were flying saucers from outer space is extremely improbable. Although I do believe in the existence of intelligent life elsewhere in the universe, the distance between stars is so great that different planetary civilizations may not ever be in contact with one another. Furthermore, contact by radio signals would be enormously cheaper and more likely than contact by spaceships.

Flying saucers or not, there's a natural explanation for fallstreak holes. They are formed when an airplane flies through a cloud of supercooled water droplets, which condense on the surface of the wings and create tiny ice crystals. These then form the seeds around which larger ice crystals grow rapidly. When the ice crystals are heavy enough, they drop out of the cloud, leaving a circular or elliptical hole, which can be as large as 25 miles in diameter. The process is fast; fallstreak holes can be created in an hour or less.

To understand better how these unusual phenomena occur, we need to look at water and its phases. Air in the atmosphere consists mainly of nitrogen and oxygen, but it also has a small amount of gaseous water vapor and other gases. When water vapor cools sufficiently, it condenses into liquid water. (See the essay "Morning Mist.") A cloud, in fact, consists of very tiny drops of liquid water floating in the air.

Water can exist in three phases: solid (ice), liquid, and gas (vapor). The conditions for each phase are determined not only by temperature, but also by pressure. For example, lowering the pressure makes it easier for liquid water to evaporate into gaseous water; there's less resistance for the liquid water molecules to escape into the air. At sufficiently low pressure, ice can evaporate directly to vapor, without going through the liquid form, and vapor can condense directly into ice.

In ice, the molecules of water are rigidly bound together in a crystalline, lattice-like arrangement, as illustrated in the essay "Snowflakes." Cold molecules of liquid water, even colder than the freezing point of water, what we call "supercooled," will not turn into ice without a "seed" in their midst, a speck of dust or tiny ice crystal that can act as a scaffold to begin building the crystal lattice. Under the right atmospheric conditions, tiny drops of water in a cloud can be supercool. They are so small that many of them do not have seeds to catalyze the

formation of ice crystals. They need some kind of disturbance. When an airplane passes through such a cloud of supercooled water droplets, it sheds ice crystals off its wings. These seed the cloud.

Once the seeded liquid water droplets in the cloud have become ice crystals, and under the right low-pressure conditions, gaseous water vapor in the cloud can condense directly onto the new crystals, causing them to grow. Eventually, they become so heavy that they fall out of the cloud, removing much of the liquid water that was in it. The rest evaporates. In sum, a region of the cloud has been totally emptied of liquid water. Visibly, a hole in the cloud has appeared.

Fallstreak holes, dependent on airplanes for their creation, are a modern phenomenon, never seen before the twentieth century. There are other human-made phenomena observed only in recent times. When I lived in Pasadena, California, the San Gabriel Mountains often appeared in silhouette, foregrounded by a beautiful amber mist. Unfortunately, this lovely apparition was caused by smog, a human-made by-product of burning fossil fuels. We are often not aware of the unintended side effects of our creations and industry.

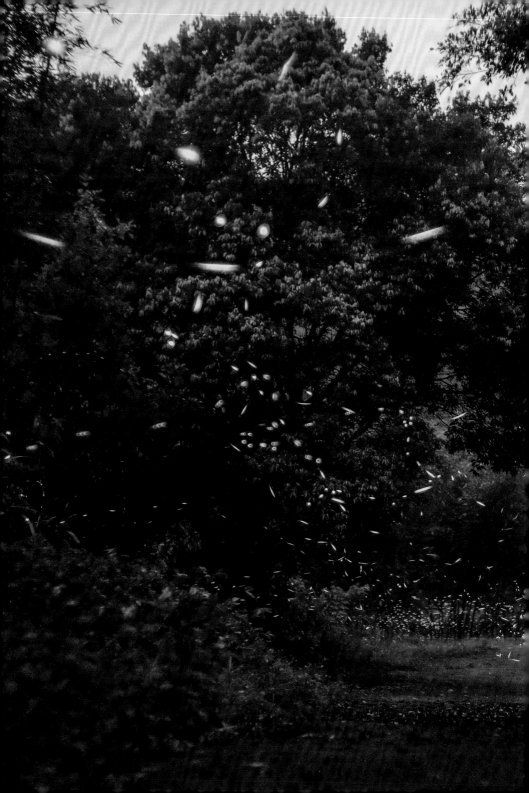

FIREFLIES

I grew up in Tennessee. On many a warm, humid summer night, I would go walking in a field near our house and become dazzled by the light show performed by fireflies. In the modern world, we're accustomed to incandescent light bulbs, LEDs, and other concentrated forms of light, all human made. But nature has been making fireflies for at least 100 million years. Finding yourself in the middle of a swarm of fireflies feels like attending a concert of light, where the cost of admission is simply the willingness to be present in the world and observe what's going on.

How do they do it, those fireflies? It's a chemical reaction called bioluminescence, found in other organisms as well as in fireflies and discussed in the essay "Bioluminescence." When oxygen combines with two other chemicals, adenosine triphosphate and luciferin, the reaction produces light. The word "luciferin" comes from the Latin words *luc,* meaning "light," and *fer,* meaning "bring" or "carry." Essentially, the electrons in the atoms move to lower energy levels and release that energy differential in the form of light, just as when wood mixes with oxygen in a fire and produces light. But unlike fire, which produces heat as well as light, the chemical reactions in bioluminescence produce a cold fire.

The chemical reaction in fireflies begins when oxygen is taken in

and ends when the oxygen is cut off. That's how the flash of light starts and stops. Where does the oxygen come from? Fireflies don't have lungs, but they do have little tubes that transport oxygen from the outside and store it in small bodies inside each cell called mito-chondria. (Mitochondria are the parts of biological cells where energy production takes place.) A firefly can release this stored energy quickly by producing an intermediate chemical, nitride oxide, which itself can be manufactured quickly and then dismantled quickly. The entire chemical reaction is completed in a fraction of a second, well-timed to give predators a chance to take note, but not long enough to exhaust the firefly.

Most of the unusual traits of animals, like the flashing of fireflies, were developed through the process of natural selection. In the long evolutionary history of the animal, such traits had survival benefit, or were by-products of traits that had survival benefit. Biologists believe that the flash of a firefly is a warning signal. Fireflies produce a chemical that is distasteful, but they have to communicate that distastefulness to potential predators. More directly, they have to identify themselves as fireflies. Hence the flashing. Say you're a predator, willing to make any small insect your dinner. If the menu is clearly labeled, you go for the tasty items and avoid the ones that sicken you.

Fireflies also may use their flashing in the mating game. Different species have different flashing patterns, and a male firefly can use its distinctive flash to signal females of the same species.

A peculiar and only partially understood aspect of the behavior of some species of fireflies is the synchronization of their flashing. When a bunch of such fireflies first find themselves together in a field on a summer night, each insect in the group flashes at different random times and at different rates, like blinking Christmas tree lights. But after a minute or so, even without a boss firefly giving orders, all the fireflies

of this species have adjusted their bodies so that they flash on and off in total synchrony. Such collective behavior cannot be understood by the analysis of a single firefly. It's an example of what scientists now call emergent phenomena—behaviors of complex systems that are not evident in their individual parts. We understand all the biology and chemistry of individual fireflies, but the synchronization of flashings of a collection of the insects involves a complex interaction between many of them.

A similar phenomenon is the massive dirt mounds constructed by termites, called termite cathedrals. The mounds have elaborate passages and galleries to control air flow, temperature, and humidity. To build such a complex structure, there would seem to be some kind of master plan, overseen by a general contractor. But individual termites are blind, insensitive to the shape of the mound, much less its design. Somehow, these fantastic structures are created by the collective action of the full colony of termites.

Personally, I find the flashing of fireflies just as beautiful when they do so at random as when they do so in unison, just as I find the shapes of clouds beautiful even when they are amorphous, or the random positions of stars in the sky. If we never went out of our human-made houses, we could never imagine fireflies, clouds, and stars. We would never experience the awe and wonder and exquisite unpredictability of the natural world.

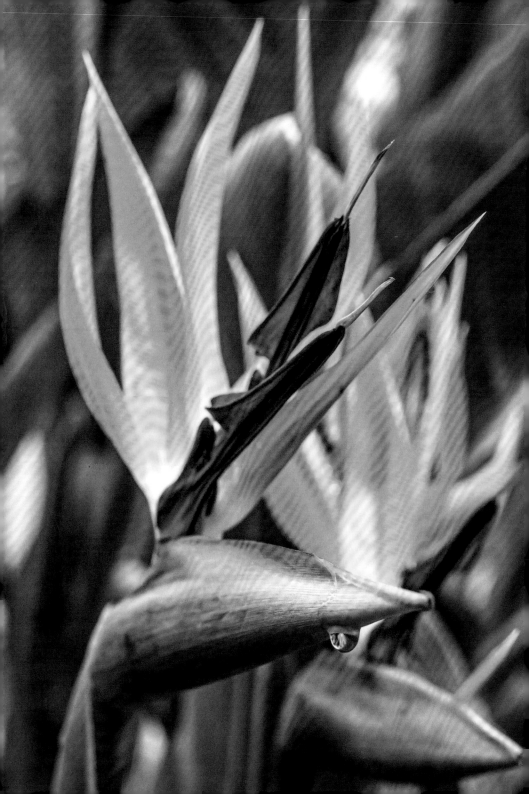

FLOWERS

Earth laughs in flowers.

—Ralph Waldo Emerson,
"Hamatreya" (1847)

When I was a graduate student at the California Institute of Technology in the 1970s, I sometimes went AWOL from my research to visit the botanical gardens at the Huntington Library, in San Marino. There, I would quietly stroll through the vast sprawl of specialized grounds, including the Japanese Garden, the Desert Garden, the Chinese Garden, and others. My favorite was the Shakespeare Garden, which displayed most of the plants and flowers mentioned in the Bard's poems and plays. In each section, a plaque planted in the ground was inscribed with the relevant line or verse. To name a few, there were pansies and rosemary from *Hamlet*, violets and thyme from *A Midsummer Night's Dream*, daffodils and carnations from *The Winter's Tale*, and daisies from *Love's Labor's Lost*. I always felt refreshed from these visits, elevated by the beauty of the flowers. Although it may sound trite, flowers make me happy.

Although not mentioned in any of Shakespeare's plays, one of the most dramatic and colorful flowers is the crane flower, also known as the bird of paradise. Its scientific name is *Strelitzia reginae,* in honor of

Queen (Regina) Charlotte of Mecklenburg-Strelitz, who was married to George III, king of Great Britain and Ireland from 1760 to 1801. The flower is indigenous to South America.

Crane flowers, blue tangos, treasure flowers, hibiscuses, lady slipper orchids, blue passion flowers. Why do flowers often have such extravagant colors? Certainly not for the pleasure of us human beings, although we do indeed get much pleasure from beholding them. Instead, evolutionary biologists agree that the purpose of floral color is to attract bees and birds, who gather pollen from one flower and then carry it to pollinate other flowers. The crane flower, for example, is pollinated by sunbirds, which perch on the "beak" of the flower. Their weight causes the flower to open and transfer its pollen to the bird, which then flies to another flower. Plants whose pollen is carried by wind rather than by insects or birds, like dandelions, cattails, corn, and barley, typically have rather dull flowers. If you see a plain-colored plant, you can be pretty sure it doesn't know much about the birds and the bees.

One can view flowers as the sexual organs of plants. Like animals, flowers have male sperms and female eggs (a fact this writer was surprised to learn). The male sperms reside within the grains of pollen. The eggs are enclosed within a flower's female parts, which are called stigma. Why does reproduction require the union of sperms and eggs? As we know today, each sperm and each egg contains its own DNA. The union of two sets of DNA produces an offspring with DNA different from either parent, contributing to an increasing diversity. Such genetic diversity, in turn, allows greater adaptability to changes in the environment and thus greater survivability of the organism and its descendants. Thus, over the long history of evolution, plants would have developed their flowers as a strategy for survival. The

sperm from one plant fertilizes the eggs of another. (Some plants are self-pollinating.)

It was a German naturalist named Christian Konrad Sprengel (1750–1816) who first recognized that the function of the colors in flowers is to attract insects and birds for the purpose of pollination. In fact, Sprengel influenced Darwin. In his book *The Effects of Cross- and Self-Fertilization in the Vegetable Kingdom,* Darwin wrote that "long before I had attended to the fertilisation of flowers, a remarkable book appeared in 1793 in Germany, 'Das Entdeckte Geheimniss der Natur,' by C. K. Sprengel, in which he clearly proved by innumerable observations how essential a part insects play in the fertilisation of many plants." Before the work of Sprengel, scientists viewed insects and birds as only accidental visitors to flowers, without appreciating their fundamental role in floral reproduction.

So far, we have been looking at the pollination of flowers from the point of view of the plant. What about from the vantage of the insect or bird, the pollinator? What does it stand to gain from the activity? Most flowers have nectar, which provides energy-rich food for a pollinator. Also, the pollen itself is a protein-rich food. That's motivation. And the color broadcasts those culinary possibilities.

But for a flower's color to function effectively to attract a pollinator, the bee or bird must be able to see it. As early as 1914, biologists discovered that various insects and birds have color vision. In fact, birds can see many more colors than humans. That capability surely has its own evolutionary history, as birds come in a wide range of colors, but that's another story. Recent studies have gone further, to show that the particular color sensitivities in the eyes of pollinators are tuned to the particular colors of the flowers they pollinate. In the words of researchers at the Freie Universität in Berlin and Hebrew University,

"On an evolutionary scale, selective spectral reflection [colors] of flowers and the colour vision systems of pollinators have developed in a mutual relationship."

Here, we see the fascinating interconnectedness and codependence of organisms in nature. Each organism is part of a vast web of life. In fact, some scientists have gone so far as to suggest that the entire Earth, both living and nonliving matter, is a complex system that regulates itself in order to permit the existence of life. The suggestion is called the Gaia hypothesis. Unfortunately, in the last century, one of those organisms, called *Homo sapiens,* has been engaged in activities endangering life on the planet.

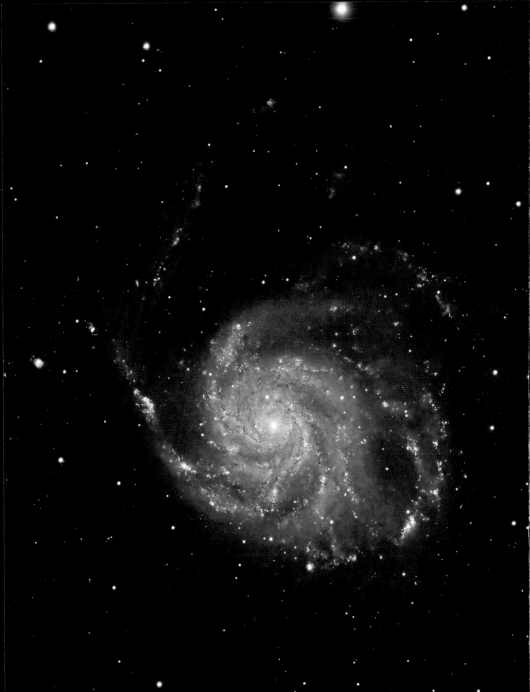

GALAXIES

On a clear and dark night, you can see a hazy white sash that arcs across the sky. That's the plane of our galaxy, the Milky Way, a congregation of about 100 billion stars. Like many galaxies, the Milky Way is shaped like a pinwheel, with a central bulge and a surrounding disk of spiraling arms. The stars in a galaxy, like the planets in a solar system, orbit the center. In most galaxies, the stars lie in a flattened disk, the result of gravitational forces plus the rotational motion of the original material that formed the galaxy. For the same reason, the planets in a solar system lie in a plane. Without overall rotation, the arrangement of planets and stars would be more spherical.

The diameter of the Milky Way is about 100 thousand light-years, meaning it would take a light ray, traveling at the speed of 186,000 miles per second, 100 thousand years to cross from one end to the other. About halfway out from the center lies our own solar system. The nearest galaxy outside of our own is Andromeda. It can be seen by binoculars with a 2-inch-wide lens or larger. But to view other galaxies, you really need a telescope, with a lens diameter of at least 4 inches.

The first time I saw a galaxy through the lens of a telescope was at the Harvard College Observatory, in Cambridge, Massachusetts. I've never seen a more beautiful thing in my life. What most struck me,

besides the beauty of the thing, was the realization that I was looking at 100 billion stars, most of them with their own solar systems. And almost certainly, some of those solar systems were inhabited by living beings, probably some of them smarter than us. Because of the vast distances of space, we will probably never be in contact with those other beings. Yet we are fellow spectators in this strange place of a universe we find ourselves in. We intelligent and living beings, constituting only a small fraction of the total mass of the universe, are the only means by which the universe can observe itself, the only means by which the universe has self-awareness. I felt a kind of kinship with those other life-forms out there, millions of light-years away.

Measurement of the sizes and distances of galaxies was made possible by a mostly deaf astronomer named Henrietta Leavitt (1868–1921), who worked at the Harvard College Observatory. For many years, I worked there myself. Leavitt's ghost still walks the passageways of the older parts of the building.

The problem of measuring distances to stars is that they come in a range of intrinsic luminosities, like light bulbs with many different wattages. If you see a light bulb in the distance at night, you can't tell how far away it is simply by how bright it appears. For a given apparent brightness, it could be of low wattage and nearby or high wattage and far away. But if you know its wattage, you can determine its distance.

"Miss Leavitt," as she was called, figured out how to determine the intrinsic luminosity, or wattage, of a class of previously known stars called Cepheid variables. These special stars pulsate in brightness in a regular way, like navigational beacons. Some Cepheids complete their light cycles in only a few days, some as long as a hundred days. By studying nearby Cepheids, whose distances were known by other means, Leavitt discovered that the lengths of the pulsation cycles

of Cepheids, called their periods, were closely correlated with their intrinsic luminosities (wattages). Cepheids with longer periods were more luminous. Once that correlation was quantified and calibrated for nearby Cepheids, you could then determine the intrinsic luminosity of a Cepheid star anywhere by measuring its period. Then, by comparing its intrinsic luminosity to how bright it appears in the sky, you could infer its distance, just as you can tell how far away a light bulb is at night if you know its wattage and observe its apparent brightness.

Before Leavitt's work, astronomers didn't know the size of the Milky Way or whether other patches of light in the sky, like Andromeda, were part of our galaxy or not. By identifying these special pulsating stars in deep outer space and using Leavitt's method to infer their distances, in 1917 the astronomer Harlow Shapley (1885–1972) was able to measure the size of our galaxy. Then, in 1924, Edwin Hubble, again using Leavitt's work, concluded that Andromeda and other aggregations of stars were entire galaxies themselves, beyond our own.

Galaxies are made of three components: stars, gas and dust between the stars, and a third material, called dark matter, which has not been identified. We know that dark matter exists, via its gravitational effects, but we can't see it.

The most visible part of a galaxy is its stars. Our sun is a star. A star is a sphere of gas, mostly hydrogen and helium, whose center is very dense and hot. Under the high heat, the atoms ram into one another with sufficient force that they fuse together, making heavier atoms in a process called nuclear fusion. Such a process creates enormous amounts of energy in the form of heat and light. The heat, in turn, produces an outward pressure, which counterbalances the inward pull of gravity. See the essay "Stars" for more discussion of stars.

Each star, or any mass, produces a gravitational force, attracting

other masses toward it. The stars in a galaxy do not fly off into space because they attract one another by their gravity. The gravity of the invisible dark matter also helps hold the stars in a galaxy.

The first stars are thought to have formed about 200 million years after the big bang, the beginning of the universe. The first galaxies would have formed about 200 million years after that.

Astronomers estimate that there are several hundred billion galaxies in the *observable* universe. I wonder whether an intelligent creature on a planet in one of those galaxies is, at this moment, looking through a telescope at us.

Here's what I mean by the *observable* universe. The universe may be infinite, but we can see only a portion of it. Beyond that point, there hasn't been enough time for light to have traveled from there to here since the big bang, about 13.7 billion years ago. Each day, we can see a little bit more of the universe because there has been one more day for light to have traveled from there to here. It is as if we found ourselves in a vast dark palace, with unlit chandeliers covering the ceiling, and suddenly the lights are turned on (the big bang). In the first few moments, we would see only the nearest chandeliers, because the light from the more distant ones hasn't yet reached our eyes. As time passed, we would see more and more distant parts of the palace. But at any given time, there would be an outer region beyond which we couldn't yet see.

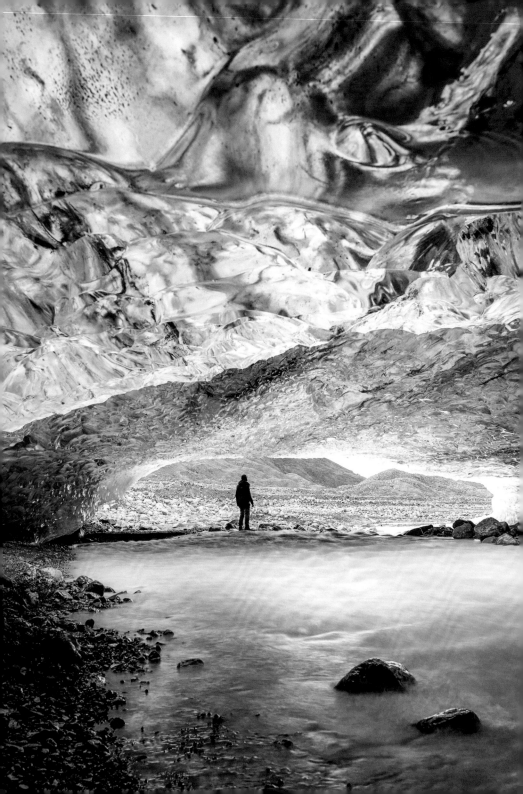

GLACIERS

Several years ago, while visiting some friends in Anchorage, Alaska, I went to see nearby Matanuska Glacier Park. It's one of the largest glaciers in the United States. The sharp-pointed slabs of snowy ice looked like giant scales on a sleeping white dragon. I felt the size and the silence and the majesty. For some reason, the glacier reminded me of Rodin's sculpture of Balzac, if it had been carved out of ice—massive and brooding.

Myths about the origin of glaciers abound. The Lang Glacier in Switzerland, the Marmolada Glacier in the Italian Alps, and the Vernagtferner Glacier in the Austrian Alps all share a similar story. It goes something like this: Long ago, a wealthy city was surrounded by lush farmland. However, the people became corrupted by their wealth. When a beggar asked for bread, they scoffed at him. To get revenge, he cursed the city. Snow began falling, and it kept falling, until the city and pastures were totally buried beneath a mountain of snow—a glacier.

The basic makeup of glaciers has been known for 2,000 years.

The Greek geographer Strabo (63 BC–23 AD), who traveled widely in the Mediterranean and Near East, described a voyage through the Alps in this way: "There is no protection against the large quantities of snow falling, and that form the most superficial layers of a glacier. . . .

It's a common knowledge that a glacier is composed by many different layers lying horizontally, as the snow when falling and accumulating becomes hard and crystallises."

Glaciers, which are mountains of packed snow and ice, cover about 10 percent of the Earth's land area and contain the largest reservoir of fresh water on the planet. They range in size from several hundred feet to over 100 miles. Glaciers can be anywhere from a hundred feet to as much as a mile thick. According to the United States Geological Survey, if all the glaciers on Earth melted, the global sea level would rise about 230 feet and flood every coastal town on the planet.

Most of the glaciers now on Earth were created between 1 million and a 100,000 years ago—fairly recently in geological history. A glacier forms when the rate of new snowfall is greater than the rate of evaporation of snow and ice, usually in valleys, which can hold and contain the snow and ice as it builds. As the glacier grows, the sheer weight of accumulating snow and ice packs and compresses the lower levels, making the snow more glanular. As the deeper snow is further compressed by more and more weight above it, many of the air bubbles are forced out, turning the snow into glacial ice, which has a bluish tint for the same reason that the sky is blue. (See the essay "Sunsets.") Sunlight consists of many different colors, corresponding to different wavelengths. The bluer wavelengths are scattered about and re-emitted by the water molecules much more strongly than the redder wavelengths, which are absorbed.

A fascinating aspect of glaciers is that they can move, typically around 3 feet per day. It's hard to imagine something so massive inching across the land. How does this happen? Gravity and high pressure. Glaciers are rigid down to about 160 feet. Until that depth, the attractive forces between water molecules are sufficiently great that all the ice is bound together, as one solid mass. However, at greater

depths, the pressure is so large that different layers of ice essentially become detached from one another, and the material can flow, like a liquid. It's called plastic flow. If a glacier is adjacent to ground at lower elevations, under the force of gravity the bottom layers can begin to flow downhill. In this sense, a glacier is a very slow river. Strabo, and other early observers of glaciers up until modern times, could not have recognized this feature.

Glaciers can be used to map out climate change over the last million years or so. Progressively deeper layers in a glacier were deposited at progressively earlier times, so that digging into a glacier represents time travel into the past. By analyzing the air bubbles trapped at each layer, geologists can determine the Earth's atmosphere at that era. The relative concentrations of particular gases also reveal the temperature at the time the layer was laid down. Using these techniques, geologists have been able to conclude that since the Industrial Revolution, around the mid-eighteenth century, atmospheric carbon dioxide has been increasing, leading to global warming. There's also a runaway feedback loop. When global warming causes glaciers to melt, less land is covered by white ice and snow, which reflect sunlight back into space. More heat is absorbed by the Earth. Temperatures rise. And the melting is accelerated. Glaciers are thus silent witnesses to human habitation on Earth.

The earliest known picture of a glacier portrays the "Rofentaler Eissee," in the Austrian Alps. It was painted in watercolors in 1601 by Abraham Jäger; the original is in the Tiroler Landesmuseum Ferdinandeum in Innsbruck. According to records of the time, the glacier had very large flow velocities, up to 12 meters per day, and filled the valley between the mountains with a lake 1,700 meters long.

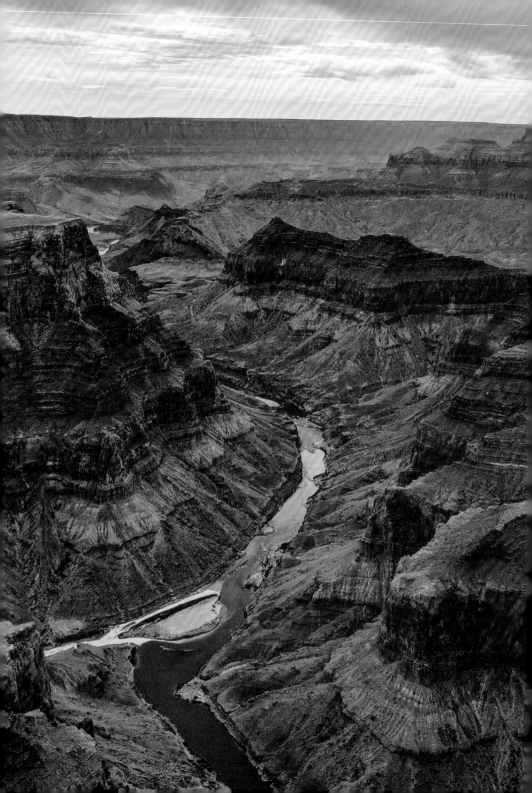

GRAND CANYON

The first White explorer to travel down the Colorado River through the Grand Canyon was John Wesley Powell (1834–1902), a geologist, army soldier, and professor at Illinois Wesleyan University. His first trip occurred in 1869. It was a hazardous journey. The Colorado River is full of fast-moving currents, white-water rapids careening over sharp rocks, and, on the overlooking mesas, Indigenous Americans who did not wish intruders well. On May 24, 1869, Powell launched his four small boats, which he had designed himself, from Green River, in Wyoming Territory. The Green River flows into the Colorado. Powell's crew consisted of ex-trappers, mountain men, and Civil War veterans like himself. From his journal entry of June 2, 1869:

> At a distance of from one to twenty miles from this point a bril-
> liant red gorge is seen, the red being surrounded by broad bands
> of mottled buff and gray at the summit of the cliffs, and curving
> down to the water's edge on the nearer slope of the mountain.
> This is where the river enters the mountain range—the head of
> the first canyon we are to explore, or, rather, an introductory
> canyon to a series made by the river through the range. We have
> named it "Flaming Gorge." The cliffs or walls we have found
> to be 1,200 feet high. You must not think of a mountain range

as a line of peaks standing up out of the plains, but as a broad platform, 50 or 60 miles wide, from which mountains have been carved by the waters. You must conceive, too, that this plateau has been cut up by gulches, ravines and canyons in a multitude of directions, and that beautiful valleys are scattered about at varying altitudes.

The Grand Canyon began forming about 2 billion years ago, with rocks that solidified out of the molten lava in the Earth's interior and other rocks produced from intense pressure. Later rocks were deposited, layer after layer, on these foundations.

Next, the huge slabs of rocks underlying the Earth's surface, called tectonic plates, in the region of Arizona, Nevada, Utah, and Colorado, slid over each other (disturbed by heat from the Earth's core) and began lifting the base to form the high and flat plateaus of the Grand Canyon. (See the essay "Volcanoes.") According to radioactive dating of the rocks, this uplift occurred 30 to 70 million years ago. The Kaibab Limestone, the highest plateau in the region, is 9,000 feet high.

Tectonic uplift elevates the ground at an average rate of about 0.1 inch per year. In human terms, that's not going to set any speed records. But geology is patient. In 50 million years, such uplift could produce a mountain or plateau 400,000 feet high. We don't see such high mountains because of gravity. For a mountain higher than about 29,000 feet, the weight of the mountain on each square inch at the bottom is so great that the base rock liquefies and can no longer support the weight of the rock above it. Indeed, Mount Everest, the highest mountain on Earth, has an elevation of this maximum height. On planets with weaker gravity, mountains are higher. On Mars, for example, with a gravity two and a half times less than Earth's, we've observed mountains as high as 70,000 feet.

The canyons between the high plateaus of the Grand Canyon were formed by the Colorado River and erosion. The river has been carving away rock for the last 5 to 6 million years. (Again, all these determinations of ages have been made by radioactive dating of rocks in the region. See the essay "Ha Long Bay.") On its 277-mile journey through the canyon, the Colorado River drops about 2,000 feet, giving it an average speed of 4 miles per hour, although the current can be much swifter in certain sections. This flow speed, plus occasional flooding, is sufficient for the river to carry large rocks and boulders, which scrape across the ground beneath like sandpaper and slowly wear it away. Ordinary erosion, caused by rainfall, also helps carve out the canyon. Unlike valleys, which are low-lying areas surrounded by hills or mountains, canyons have extremely steep walls, sometimes nearly vertical cliffs, caused by rapidly flowing rivers between the canyon walls.

Geologists aren't sure about the origin of the Colorado River. There was a river as big as the Colorado, dated at 55 million years ago, flowing from Utah into Arizona, although in the opposite direction of the current Colorado River. The river is much younger than the rocks through which it winds. From radioactive dating, we do know that the lower section of the river, in Nevada and Arizona, is younger than the upper section, in Utah and Colorado.

According to the Hopi Indigenous Americans, who have lived in the area of Arizona for thousands of years, the Grand Canyon is the location of the mystical *sipapu,* the gateway between the living and the dead. Living human beings arrive from the underworld by passing through this portal.

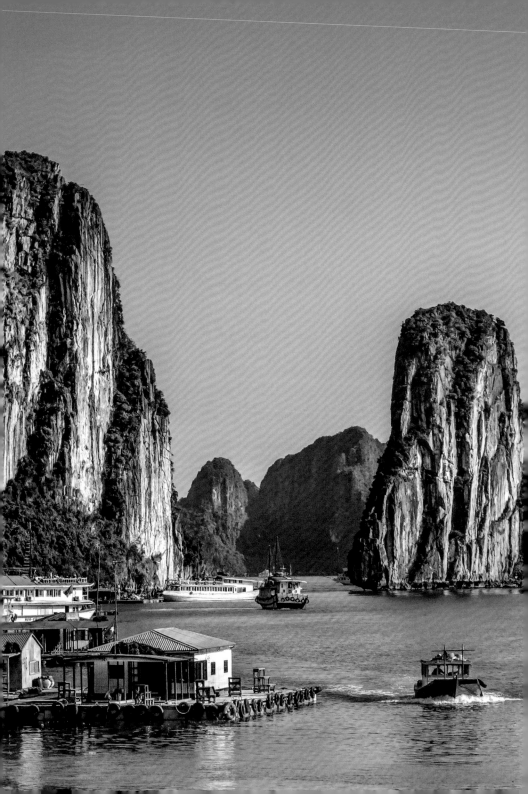

HA LONG BAY

Several years ago, I made a trip to Ha Long Bay in northeast Vietnam. It's one of the wonders of the world. Steep, miniature mountains covered with green jungle rise up out of the ocean. There are something like 1,600 of these micro mountains. They look like a scene in a sci-fi movie, a surreal seascape on an alien planet. Or perhaps emerald warts on a giant serpent's back. But beautiful. In 1994, Ha Long Bay was named a World Heritage site. I took pictures, but the pictures seem photoshopped.

The name Ha Long, or Vịnh Hạ Long in Vietnamese, means "descending dragon." Legend has it that the gods sent dragons to the bay to help the Vietnamese fight off foreign invaders. (Historically, Vietnam was invaded by China, Japan, France, and other nations.) According to the legend, the dragons began shedding jewels and jade, which turned into little islands. Other mountains rose out of the sea to block the ships of the invaders.

The early Vietnamese Confucian scholar and poet Nguyễn Trãi (1380–1442) described the mountains of Ha Long Bay in this way: "a marvel of the earth erected towards the high skies."

The micro mountains in Ha Long Bay are a geological feature called karst towers, which are tall structures made of dissolvable rock. The karsts in Ha Long Bay are made of limestone (calcium carbon-

ate) dating back to the Carboniferous Period of the Earth's past, 300 million years ago. During this period, the amount of carbon dioxide in the air was higher than it is today, causing the temperatures to be higher. Higher temperatures, in turn, were associated with the greater humidity needed for the erosion that carved the rocks. (But after CO_2 substantially decreased from that peak, several million years ago, it has sharply risen again due to human-made fossil fuel burning.) At the time, marine life-forms included mollusks, crustaceans, starfish, and sea urchins; terrestrial life included insects and spiders, millipedes and centipedes. The large animals, like dinosaurs, did not appear until about 250 million years ago.

Karst towers can be found in other tropical regions throughout southeast Asia, most notably in the Guangxi province of southern China. Usually, they occur on land. In this respect, the towers in Ha Long Bay, springing out of the sea, are unusual, adding to their striking appearance.

The karst towers of Ha Long Bay, as well as karst towers elsewhere, were created by the movement of vast slabs of rock called tectonic plates underneath the Earth's crust. (See the essay "Volcanoes.") The particular topography at Ha Long Bay was caused by fractures in the rocky slabs moving in pairs, one slab sliding over the other, causing alternating raised and lowered blocks of rock.

One of the most dramatic features of the karsts of Ha Long Bay is their steepness, the sharp drop from the top of each micro mountain to the ocean below. That steepness was created both by the tectonic activity that initially formed the little mountains and by millions of years of erosion. The latter required a humid, warm climate, and plentiful rainwater, which would have dissolved much of the limestone and carved the sharp shapes that we see today. Geologists believe that the detailed landscape of Ha Long Bay, including the topography between

karst towers, was created about 8,000 years ago, by the movement and melting of glaciers.

It's astonishing that scientists can reckon the ages of things millions of years old, with origins long before recorded history and even long before the emergence of our own species, *Homo sapiens,* about 300,000 years ago. The principal technique for geological dating uses radioactive atoms, which are atoms that change into other atoms at a very definite rate by ejecting or capturing subatomic particles.

By measuring the proportions of the initial atoms to the daughter atoms they create, we can date the material, assuming that none of the daughter atoms were present at the beginning.

For example, a form of potassium called potassium-40 slowly changes into a form of argon called argon-40. The time for half a sample of potassium-40 to become argon-40, called its half-life, is 1.3 billion years. In other words, a rock with an equal amount of potassium-40 to argon-40 (half the potassium changed to argon) would be 1.3 billion years old. A rock with three times as much potassium-40 as argon-40 would be younger, 0.54 billion years old; a rock with one-third as much potassium-40 as argon-40 (three-fourths the potassium changed to argon) would be 2.6 billion years old, and so on.

In a similar manner, geologists and physicists have used radioactive dating to determine the age of the entire Earth, about 4.5 billion years.

I am constantly amazed that we human beings have been able to understand so much about our world, including events that happened many, many human lifetimes ago. With our highly evolved brains, we have easily transcended the limits of time and space decreed by our physical bodies.

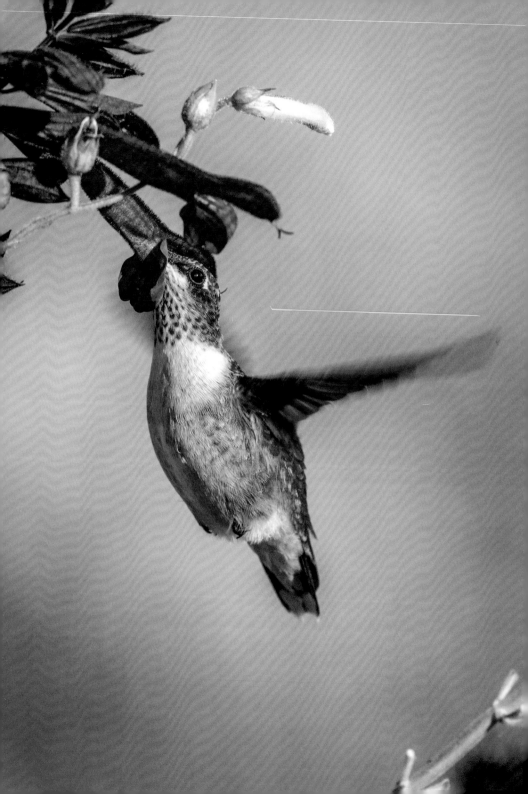

HUMMINGBIRDS

My wife and I spend the summers in Maine. One summer, we had two or three hummingbirds darting about the feeder we hung on the veranda at the south end of our house. I quietly watched them from a back window, afraid of scaring them off. The birds seem to defy gravity. They hover. They float. They are "air within the air," said Pablo Neruda. They are a painter's accents, splashes of color on the canvas of the world, with iridescent blue and green bodies and lavender struts on the undersides of their wings.

You can't see the color of their wings because they are flapping back and forth 50 times per second. To supply oxygen for such an engine, the highest metabolism of almost all animals, the heart rate of a hummingbird is an incredible 1,200 beats per minute. Oxygen consumption per weight is ten times that of top human athletes.

The more you know about hummingbirds, the more amazing they seem. Yet you can calculate a lot of the design specs of the hummingbird from basic physics and biology. The hummingbird earns its living by being able to hover in midair while sucking the delicious nectar from flowers. How fast must it flap its wings to perform such an acrobatic feat? There are a couple of different ways to calculate this required speed. Slow-motion videos of hummingbirds show that their wings move in a rotary fashion, changing shape and angle throughout

each cycle. If you require that the bird achieve sufficient aerodynamic lift to support its weight, as discussed in the essay "Birds," its wing tip must move at about 1,500 centimeters per second. That corresponds to a rate of about 50 flaps per second, as observed. Another perspective comes from noting that the H-bird appears to hover in midair. To do so, it must not fall (under the downward pull of gravity) more than about a tenth or twentieth its size before another flap of its wings. That gives a rate of around 40 to 50 flaps per second.

You can also compute the required heart rate. A human being can flap its wings—i.e., arms—about four times per second. (I have personally verified this result in front of my appalled students at MIT.) Since the heart rate of an exercising human is around 125 beats per minute, the required heart rate of an H-bird, needing 50 flaps per second, should be 50/4 times larger, or about 1,560 beats per minute, assuming that the H-bird's heart mass has about the same ratio to its wing muscle mass as our human heart mass has to our arm muscle mass. That number is pretty close to the figure observed.

With that fantastic heart rate and necessary energy expenditure, the H-bird needs to eat essentially all of its waking hours, and it needs to conserve energy when it is sleeping. At night, H-birds go into a very deep sleep, like hibernating animals, in which their heart rate drops as low as 50 beats per minute. Their body temperature drops from about 100 degrees Fahrenheit to 50 degrees. All of these numbers vary a bit depending on the species of H-bird.

The enormous metabolism of hummingbirds presents other challenges. When muscles are working hard, they produce a lot of heat. And that heat must somehow be removed from the animal. Many animals dissipate heat by rapid panting or by sweating (evaporating water from their skins). Hummingbirds cool down with exhaled air.

They also have a minimum number of feathers blocking evaporation from their bodies.

With all of these explanations of how a hummingbird manages to hover in the air, we have not addressed the question of why. Why does an H-bird need to hover? Its food is the nectar of flowers. Only by hovering can it position itself to stick its long tongue into the funnel of a flower to extract the nectar and hold that position while it is eating. A few other birds also feed on the nectar of flowers but use different strategies for getting the meal. For example, bananaquits eat the nectar of the common aloe, but its stem is strong enough that the bird can perch on it. Myzomelas also eat nectar but find flowers near enough to trees that they can perch on their branches.

In sum, the H-bird hovers in order to better extract its food, and the bird must eat food voraciously and constantly to supply the energy needed to hover. It may be difficult to say which need came first in the evolutionary history of these unique birds.

In any case, it's all a matter of science, like the swing of a pendulum. It's all material. But when I'm looking at these birds, suspended in space, I don't think numbers or gravity or heat dissipation or evolution. I just watch and am amazed.

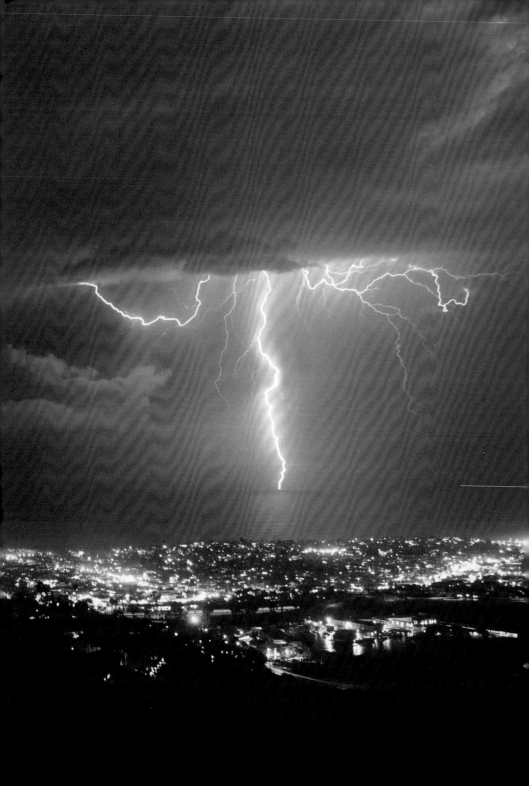

LIGHTNING

Lightning may be the most dramatic natural phenomenon on our planet. Nearly all ancient cultures associated lightning with the actions of the gods. The most familiar god of lightning is perhaps Zeus, king of the second generation of Greek gods. Zeus was the son of Cronus, king of the first generation, the Titans. According to legend, Cronus was a jealous and fearful god who swallowed most of his children and imprisoned his brothers, the one-eyed Cyclopes and the fifty-headed Hecatoncheires. Planning for the inevitable battle with his elders and looking for allies, Zeus freed the Cyclopes and the Hecatoncheires. In gratitude, the Cyclopes, master craftsmen, forged lightning bolts and gave them as a gift to Zeus to be used as weapons. Zeus reciprocated by using lightning bolts in the war against the Titans. He also employed the weapon to kill anyone challenging the gods' authority.

We know today that lightning is an intense flow of electricity. The ancient Greeks understood that when amber, a fossilized tree resin, was rubbed with other materials such as cloth, it could attract light objects. Indeed, the word "electricity" comes from *elektron*, the Greek name for amber. This kind of electricity produced by rubbing certain objects together is called static electricity. It's different from the flow of electricity in lightning.

Pioneers of the modern understanding of electricity include Luigi

Galvani (1737–1798), Alessandro Volta (1745–1827), Charles du Fay (1698–1739), and Benjamin Franklin (1706–1790). Du Fay and Franklin were the first to recognize that electricity is associated with two kinds of electrical charge. Franklin named them positive and negative. However, he believed that electrical charge originated from a single electrical fluid. An object with a surplus of this fluid would be negative; an object with a shortfall would be positive.

Around 1900, and especially with the experiments of the New Zealand physicist Ernest Rutherford (1871–1937), scientists learned that electricity is carried by subatomic particles called protons and electrons. (Later, even more exotic particles called quarks were discovered, with fractional electric charge.) An atom consists of two electrified parts: a tiny nucleus, containing protons, each of which has one unit of positive electrical charge; and electrons, each of which has one unit of negative electrical charge and which orbit the atomic nucleus. Atoms are normally electrically neutral, with an equal number of protons and electrons. In that way, the total positive charge is exactly balanced by the total negative charge. Molecules, such as the water molecule, consist of atoms weakly bound together by electrical forces.

The origin of lightning is a separation of electrical charges within a thundercloud. There are two ways this charge separation occurs. The first is caused by friction, like the electrical charging of amber when it is rubbed. Relatively warm water vapor rises up from the ground into the thundercloud and condenses into liquid water droplets as it cools. The rising water droplets collide with water molecules and ice crystals already in the cloud and have some of their electrons stripped off. Thus, the rising water droplets now become positively charged, as there isn't enough negative charge to counterbalance the positive charge in their atomic nuclei. Meanwhile, the heavier water droplets

and ice crystals that have received the stripped electrons, and thus become negatively charged, fall down to the lower part of the cloud. In sum, the cloud has become electrically polarized, with net positive charge at its top and net negative charge at its bottom.

The second cause of charge separation, or polarization, within the cloud involves freezing. The inner portions of the rising water droplets freeze and, in the process, take electrons away from the outer liquid portions. Thus, the inner portions of each of these tiny wet snowballs is negatively charged and the outer portion is positively charged. Air currents rip the outer portions off and carry them up to the top of the cloud, while the negatively charged icy centers sink to the bottom.

Although the above description of electrical charge separation in a thundercloud is basically correct, the full picture is more complex and not fully understood. There are probably different regions of positive and negative charge at different altitudes within the cloud and a small positive charge at the very bottom of the cloud. In any event, there is a large, negatively charged region near the bottom of the cloud, which can further polarize the ground below, attracting positive charge toward the area directly beneath the cloud and repelling negative charge away from this area. (Opposite charges attract; like charges repel.)

The separation of electrical charge, both from the top of the cloud to its bottom, and from the bottom of the cloud to the ground below, produces an invisible electric force, similar to the invisible magnetic force surrounding a magnet. The stronger the charge separation, the stronger the electrical force. That electric force attempts to accelerate electrons through space, from negatively charged areas to positively charged areas. Such a flow of electrons is the definition of electricity.

In the early stages of thundercloud formation, the air between charged areas acts as an insulator and inhibits the flow of electrons.

Eventually, however, with greater and greater electrical polarization and stronger and stronger electric force, the insulation breaks down. The electrons in the atoms of air between the cloud and the ground are stripped off and able to flow freely. Then, in a sudden event lasting only about 30 millionths of a second, we have a lightning bolt, in which huge numbers of electrons flow from the bottom of the cloud to the top (in cloud-to-cloud lightning) or from the bottom of the cloud to the ground (in cloud-to-ground lightning). Any net electrical charge transferred to the ground would have to be transported back to the atmosphere to restore overall charge neutrality. There are several mechanisms for such transfer, including electrically charged water vapor and the ongoing exchange of electrical charge between the ground and the atmosphere.

A typical lightning bolt has about 300 million volts of electricity and a total energy of about 1 billion units called joules. To put these numbers in perspective, most electrical outlets in the United States are 120 volts, and most households use about 100 million joules of energy per day. Thus a single lightning bolt could provide enough energy to power a typical household for ten days.

The visible light of a lightning bolt is produced when the surge of energy is partly absorbed by nitrogen atoms in the air. The atoms release that energy as visible light.

Around the world, there are about 9 million lightning strikes per day. Most lightning happens in the tropics, where there are the largest number of thunderstorms. The record holder for lightning is in Venezuela. Near the Catatumbo River in that country, lightning occurs about three hundred nights per year.

I once had a bizarre experience with something called ball lightning, a quickly moving, luminescent sphere of electrically charged air about the size of a basketball. Although ball lightning is not understood, it

is associated with thunderstorms and the electrical charge separation they produce. I was standing on the outside deck of my house during a thunderstorm when a shining, crackling globe sailed past me, went through an open door, and dissipated with a bang inside the house. The entire event lasted about three seconds. It happened only once, and I've never again seen anything like it.

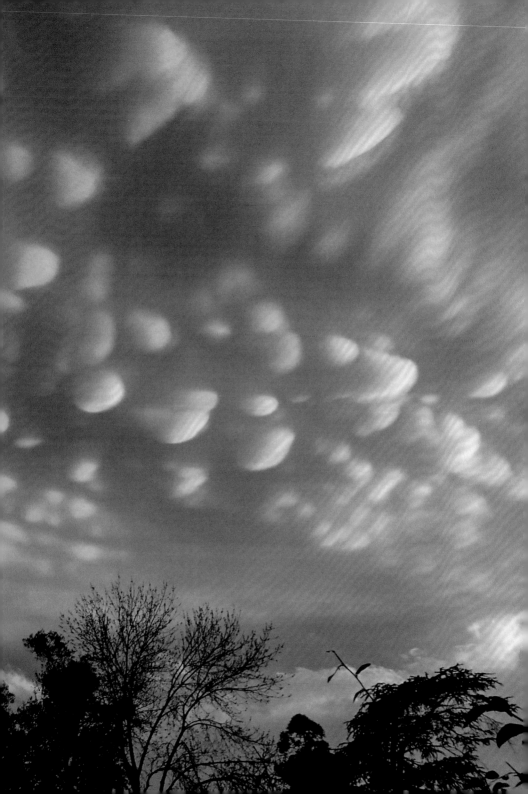

MAMMATUS CLOUDS

I am the daughter of Earth and Water,
And the nursling of the Sky;
I pass through the pores of the ocean and shores;
I change, but I cannot die.

—Percy Bysshe Shelley,
"The Cloud" (1820)

Mammatus clouds, like fallstreak holes, are another of those phenomena that are not only beautiful but plain weird. Unlike fallstreak holes, which are caused by airplanes zooming through clouds, mammatuses (or, remembering my high school Latin, perhaps the plural should be mammati) are totally natural. Mother Nature creates these strange-looking pouches on the undersides of clouds totally by Herself, without our help. Occasionally, you see something outdoors that you can't believe is real, as if it were sculpted or painted by a drugged artist, even though it is completely natural.

Clouds, like snowflakes, come in an infinite variety of shapes. That variety stems from an enormous range of determining factors inside clouds and in their vicinity: fluctuations in temperature, density, humidity, wind, and the underlying terrain below. It's difficult to predict the behavior of clouds and impossible to predict their specific

shape. In principle, if we had complete data about the motions of every molecule of air in a region with infinite precision and a giant computer, we could predict the formation and shape of clouds. But there is no way we could get all that data. Such is the situation for many large and complex systems in science, including the human brain. We understand the basic science and all the cause-and-effect relationships, but we cannot get enough data to understand or predict everything that's going on.

Before turning to mammati (I'm going to stick with the Latin), let's first look at the science of clouds in general. A cloud consists of water vapor and tiny droplets of water. First, the color. Clouds are white because sunlight is white, and that light is absorbed, reflected, and scattered about by the dense congregation of water droplets in the cloud. The spreading out of the colors of sunlight in rainbows (see the essay "Rainbows") does not happen in clouds because the light in clouds is diffused by many scatterings with many raindrops, whereas each light ray striking the eye from a rainbow has reflected from a single raindrop.

Clouds are formed by warm water vapor evaporating and rising from the warm Earth. The Earth is heated by the Sun, and the air in closest contact with the Earth, including water vapor, receives that warmth. As you go up in altitude, the rapid motions of the molecules of warm air and water vapor continuously slow down as they rub against slower molecules higher up, and the temperature drops. (Temperature is just a measure of the average speed per molecule of a group of randomly moving molecules.) At 8,000 feet, for example, a typical height of low clouds, the temperature has already dropped to 30 degrees Fahrenheit. The highest clouds, cirrus, can form at 30,000 feet, where the temperature is about -48 degrees. Cirrus clouds are composed mostly of ice crystals. At 40,000 feet, the temperature has

dropped to -70 degrees. In addition, the air pressure falls at higher altitudes because gravity is trying to pull the air molecules down, close to the Earth, and only the most energetic molecules can rise high. (See the essay "Atmosphere.") At very high altitudes, around 60,000 feet, the temperature begins rising again, due to a large presence of ozone and the resulting increased absorption of energy from the Sun. At the very outer layers of the atmosphere, at 200,000 feet, the temperature again drops to merge with the coldness of outer space. These are the atmospheric conditions in which clouds form.

Warm air is less dense than cold air, and less dense substances always rise due to buoyancy pressures, like those that lift a balloon filled with helium or some other gas lighter than air. In sum, the warm water vapor, heated by the Earth, rises.

At a certain altitude, the temperature is low enough that the water vapor condenses into droplets of liquid water. That's when a cloud forms. Some of those liquid water droplets further condense into ice.

Why do clouds float? Why don't the water droplets in a cloud fall back to Earth? Because they are so small. A water droplet feels two forces: gravity, pulling it down; and rising air currents, pushing it up. (Air currents can also push it sideways.) The gravitational force is proportional to the weight of the water droplet, which in turn is proportional to its *volume.* The pressure force of air currents is proportional to the *area* of the water droplet, since the molecules of air push against the surface of the droplet. As we go to a smaller and smaller size, the volume of the water droplet decreases *faster* than its surface area. (For every halving of the diameter, volume decreases by a factor of eight, while area decreases by only four.) At a sufficiently small size, the air pressure force is much greater than the downward gravitational force. For practical purposes, gravity has disappeared. The droplet floats. As do clouds made of them. For the same reason,

tiny dust motes in front of a sunny window can be seen floating in the air, essentially weightless.

One of the earliest descriptions of mammati I could find comes from an article titled "'Festooned' or 'Pocky' Clouds (Mammato-Cumulus)," published by a Ralph Abercromby in the May 24, 1883, issue of *Nature* magazine. Mr. Abercromby writes that "the impression which the whole conveyed to me was that the festoons were formed by a sudden drop of the cloud. . . . Festoons are caused by a sudden failure of an ascentional current associated with showers or squalls."

Mammatus clouds get their name from the lobes or pouches hanging from the underside of the clouds. (*Mamma* is the Latin name for the female breast.) Mammati occur in dense, towering vertical clouds called cumulonimbus clouds, fed by strong rising air currents. The lobes or pouches that give these clouds their striking appearance have diameters of a half mile to 2 miles. Each lobe lasts for about 10 to 15 minutes. The lobes are made out of ice and water droplets. Causes for the formation of the distinctive lobes in mammati are not understood. Consequently, there is an abundance of theories. The lobes are denser than the rest of the cloud, resulting in their descent to the underbelly of the cloud. That descent may be coupled with a temporary cessation of upward air currents, as suggested by Mr. Abercromby. Churning and unstable air within the cloud could help carve and shape the lobes. One simple interpretation is that mammatus clouds are the opposite of the punchy-looking clouds we see looking down from an airplane, where the rising hot air overshoots the position where it is just buoyant. The mammati may be pockets of cold, dense air that fall a bit below the point where they would be just buoyant.

Although the basic physics behind clouds is understood, the explanation of mammati is still a challenge, as mentioned earlier. A relatively recent article in the *Journal of the Atmospheric Sciences,* titled

"Comments on 'The Mysteries of Mammatus Clouds,'" states that "although mammatus cloud formations have little or no direct societal impact, they are a fascinating enigma, certainly worthy of careful scientific scrutiny." It is refreshing to me that, despite the enormous progress of science, there are still physical phenomena we don't fully understand. Unsolved problems fuel the fire of our creativity.

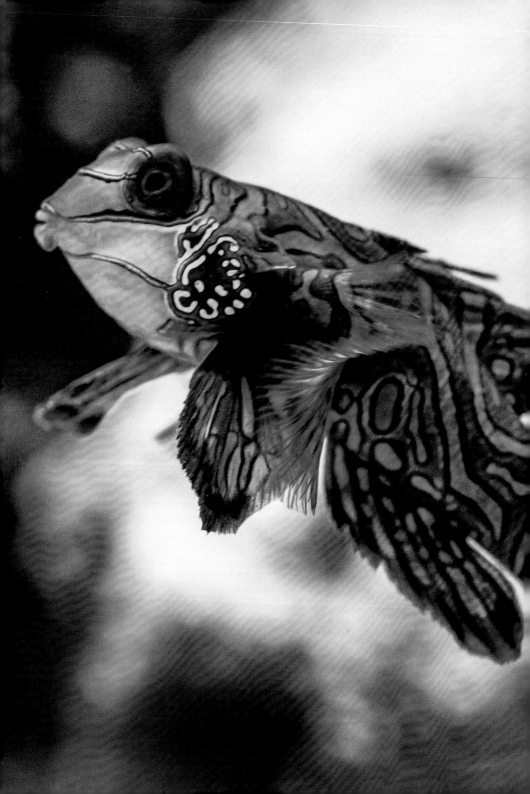

MANDARINFISH

This is how mandarinfish mate: During the day they hide within the branches of staghorn corals. At sunset, the party begins. The males swim out into the open, parading themselves in a ritual mating dance, while the females gather at the reef and peruse the possible partners. The bigger males have the best chance for romantic liaisons. In fact, a single male mandarin can mate with several females in one night. Each successful couple attaches at the pelvic fin and swims to the top of the reef. There the male releases a cloud of sperm and the female a couple hundred eggs. Then the courtship is over. The fertilized eggs take only 18 to 24 hours to hatch. After two weeks of floating about, the larvae settle into a reef.

Mandarinfish. Also known as mandarin dragonet, mandarin goby, green mandarinfish, striped mandarinfish, and the psychedelic fish. The scientific name is *Synchiropus splendidus*. In ancient Greek, *syn* means "together" and *chiropus* means "hand-foot." In Latin, *splendidus* means "glittering." The common name "mandarin" derives from the extremely vivid coloration. The fish looks like it's wearing the robes of a Chinese mandarin.

Mandarinfish can be found in warm waters. They are native to the Pacific Ocean, ranging from the Japanese Islands to Australia.

These fish are tiny. They measure only about 3 inches in length

and are sometimes used as pets in aquariums, but they are hard to keep alive because of their picky eating habits. Unlike almost all other fish, mandarinfish don't have scales. Instead, they cover their skin with a thick mucus, which protects their bodies from parasites and threatening changes in the local environment. The mandarinfish is unique in other ways. Its large pelvic fins are used for ambulating on the seafloor. The dorsal fin, which is exceptionally tall in males, has a striking orange-and-blue design as well. Their eyes are usually red with black pupils. Mandarins eat small worms, protozoans, and small crustaceans. They are skittish and avoid other fish.

The most striking feature of these fish, of course, is their extravagant coloration. The mandarinfish is one of only a very few vertebrates whose blue color comes from blue pigment in its cells rather than from a thin film of crystals on its skin.

Almost every distinctive trait of a living organism is the result of natural selection, developed over millions of years of evolution, with either direct survival benefit or as a by-product of a trait that had survival benefit. Regarding coloration in particular, Charles Darwin wrote that "when we see leaf-eating insects green, and bark-feeder mottled-gray; the alpine ptarmigan white in winter, the red-grouse the colour of heather, we must believe that these tints are of service to these birds and insects in preserving them from danger."

Here, Darwin is talking about coloration to provide camouflage. But coloration has other survival benefits as well: to attract mates, and as warnings to predators when the colored animal is poisonous. If you're poisonous, you want a potential predator to correctly identify you in no uncertain terms, well before it attempts to eat you. Thus the ornate coloration of poison dart frogs and coral snakes. Mandarinfish are poisonous as well. That's their defense mechanism. This diminu-

tive little fish has tiny spines, which inject a toxic mucus into any creature that tries to take a bite out of it.

The mandarin's most dangerous natural predator is the scorpionfish, which packs a lot of poison itself. But an equally lethal predator is us human beings. Because mandarins are so exotically colored, they are prized by the recreational fish industry and are collected for personal fish tanks. A single mandarin can sell for as much as $150. But they don't last long in captivity. In the wild, they live 10 to 15 years, but only 2 to 4 years in artificial tanks.

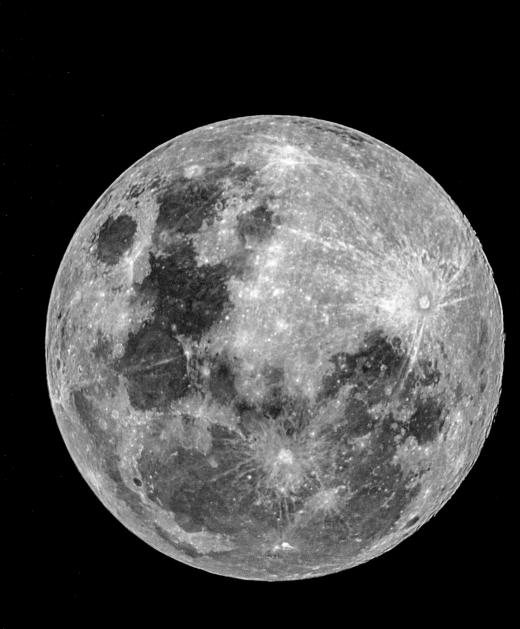

MOON

The moon was but a chin of gold
 A night or two ago,
And now she turns her perfect face
 Upon the world below.

Her forehead is of amplest blond;
 Her cheek like beryl stone;
Her eye unto the summer dew
 The likest I have known.

<div align="right">

—Emily Dickinson,
Poem 737 (1863)

</div>

The Wakaranga people of Zimbabwe have a myth about the creation of the Moon. At the beginning, God made a man and named him Moon. First, Moon lived at the bottom of the sea but then went to dwell on land. Because there was no other life on Earth, Moon became lonely and sad. God felt sorry for Moon and sent him a wife named Morningstar. During the night, Moon and Morningstar made love, giving birth to the plants and animals that populate the Earth. After two years, according to prior divine agreement, Morningstar returned to her home in the heavens. God sent Moon another wife,

Eveningstar, but she became jealous of Moon's unfaithfulness (there were other women by this time) and sent a snake to bite him. When Moon fell ill, the people of his village strangled him and threw his body in the ocean. But Moon rose from the sea and, still in love with his first wife, Morningstar, left the Earth and joined her in the sky.

Scientists have their own creation story for the Moon. Radioactive dating of rocks brought back from the Apollo 11 mission suggests that the Moon was formed about 50 million years after our solar system, about 4.5 billion years ago. (See the essay "Ha Long Bay" for radioactive dating.) The leading scientific hypothesis is that the Moon was created by a collision between the Earth and a Mars-sized planet called Theia during the infancy of our solar system. Random collisions at that early time were common, as some material did not follow the orderly motion of the planets we see today; furthermore, the gravitational influence of the planets on one another produced stray orbits. (See the essay "Fall Foliage.") According to the theory, some of the debris from the collision, most of it ripped off from Theia, formed the Moon. Most of the planets in our solar system have moons, produced by collisions and breakups of orbiting debris. At latest count, Saturn has 146.

Initially, the Moon was much closer to Earth, only a few Earth radii away. Consequently, the Moon would have appeared far larger in the sky (if there had been people to see it), and eclipses would have been much more frequent. Over a period of billions of years, the Moon slowly spiraled out to its current distance from the Earth, 240,000 miles. That outward motion was caused by the "tidal" interaction between the Earth and the Moon. The Moon's gravity, together with the rotation of the Earth, produces moving bulges in the Earth, the so-called tides. (Tides produce slight moving bulges in the ground as well as the water, but the latter are far more pronounced.) Tides

produce friction. The result is that the rotation of the Earth slows, and the Moon moves farther away. A principle of physics says that the total rotational motion, called angular momentum, of an isolated system like Earth + Moon cannot increase or decrease. The Earth loses angular momentum by slowing its spin, and the Moon gains that same amount of angular momentum in its orbital motion around the Earth by moving outward. Larger orbits have more angular momentum.

One of the most noticeable features of the Moon's appearance is its many craters, far more than on Earth. Why so many? Answer: the lack of an atmosphere and absence of erosion. While the Moon's average density is not much less than Earth's, its much smaller size lowers its gravity to only one-sixth that of the Earth, not strong enough to hold an atmosphere. Both the Moon and the Earth are constantly bombarded by meteors, which create craters if they reach the surface. For our Earth, many of those meteors burn up in the atmosphere. Furthermore, the Earth's rain, air, wind, and plant life—all related to its atmosphere—produce erosion, which evens out irregularities in Earth's surface. The Moon lacks the rain, air, and wind to produce erosion.

Another remarkable feature of the Moon is that it always keeps one side facing the Earth. That's because the Moon makes one rotation about its own axis in exactly the same time as it takes to make one orbital revolution around the Earth. That synchronization was brought about, again, by the tidal interaction between the Earth and Moon discussed above. Just as the Moon produces tides on the Earth, the Earth's gravity produces tides on the Moon. If the resulting lunar bulge did not point directly to the Earth, there would be additional gravitational forces changing the Moon's rotation and realigning the bulge with the direction to Earth. In such a way, the Moon's rotation became synchronized with its orbit around Earth. This phenomenon,

called tidal locking, is common for all of the larger moons in our solar system.

Detailed drawings of the Moon, first made around 1610 by Galileo with his new telescope, show only the particular features of one side of the Moon. Knowledge of the dark side of the Moon would have to wait until 1959 when the Soviet Union's Luna 3 spacecraft took the first photographs of the Moon's far side and radioed them back to Earth.

The Moon's largest craters are visible with the naked eye. To my mind, the splotchy surface of the Moon makes it all the more beautiful, like the amorphous shapes of clouds. In the summer, my wife and I live near a bay. On a clear night, when the Moon rises above the trees on the mainland to the east, we are treated to a spectacular sight. At first, the tops of the trees begin to glow in the darkness. The glow gets brighter and brighter, until the first tiny sliver of the silvery Moon appears. As the goddess Luna rises, more and more of her becomes visible, until she sits momentarily on top of the trees. Then she is off on her journey across the night sky.

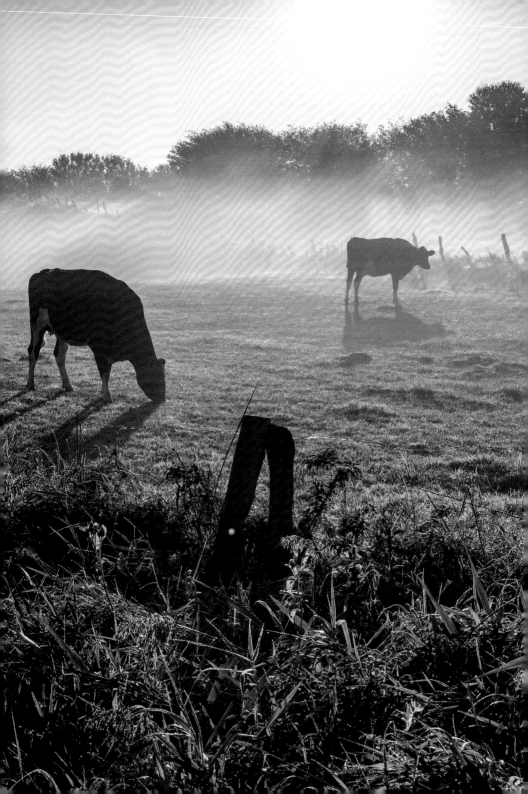

MORNING MIST

I am dust particles in sunlight.
I am the round sun. . . .

I am morning mist,
and the breathing of evening.

—Rumi,
"Say I Am You" (ca. 1250)

I live in a small town during most of the year. Almost every morning around 7 a.m., I go jogging up a hill to a grassy field and around the perimeter of the field, for as many laps as my stamina will hold out. In the cool months, I'm treated to the spectacle of a mist hanging low over the field, a soft silvery gauze. When I see this mist, I always feel that I've entered a magic kingdom, a place of dreams, with winged horses and goblins. Temporarily, I forget about my aching muscles, my huffing and puffing, and simply let myself be carried off into this fantasy land.

What causes a morning mist? After the Sun sets, the ground begins to cool off and rid itself of the day's heat. In fact, the ground radiates heat more effectively than the air. By early morning, the ground can

be several degrees colder than the air above it. As a consequence, a layer of air just above the ground gets cooled. That's half the story.

The other half concerns the condensation of water vapor in the air to make mist. There's always a certain amount of water in the air in gaseous form. When the temperature of the air drops low enough, the molecules of water floating about stick together to form liquid water, or mist.

And why does lowering the temperature cause water to change from a gaseous state to a liquid state? A water molecule is made of two atoms of hydrogen and one atom of oxygen, usually written as H_2O. An atom consists of a positively charged nucleus and negatively charged electrons orbiting the nucleus. Most atoms in isolation are electrically neutral, with equal amounts of positive and negative electrical charge that balance each other. An oxygen atom is constructed in a way that makes it easy to welcome an extra electron, while the reverse happens with a hydrogen atom; it's easy for it to give up an electron. In a water molecule, the two hydrogen atoms "share" their electrons with the oxygen atom, meaning that those electrons spend some of their time near the oxygen atom. The hydrogen atoms are then left with a net positive charge. On the other hand, the oxygen atom has now gained extra negative charge (from the electrons borrowed from the hydrogen atoms) and becomes negatively charged, as shown in the illustration below.

When water is in its liquid form, the negative (oxygen) end of each water molecule is attracted to the positive (hydrogen) end of other

water molecules and bonds with them, as shown in the illustration below.

In water, all the molecules stick together in this way. As we raise the temperature, the water molecules vibrate and spin and can jiggle a bit, their motions increasing with increasing temperature. Eventually the bonds between adjacent molecules are broken. At that point, each water molecule is a solo act floating freely on its own. The water has changed from a liquid to a gas.

The reverse happens when we cool down water vapor. The energetic gyrations and motions of the free-floating water molecules slow and diminish. At some point, the attraction between water molecules is stronger than the thermal motions pulling them apart, and the molecules bond together to make a liquid, or mist. The mist in early morning is low near the ground because the air there has cooled sufficiently for the condensations to occur. Eventually, as the Sun rises, the air heats up, the water changes once again from liquid to gas, and the mist disappears.

I always try to run (relatively) early in the morning, before my fantasy world has been burned away by the rising Sun. But, of course, the warmth of the Sun adds other pleasures.

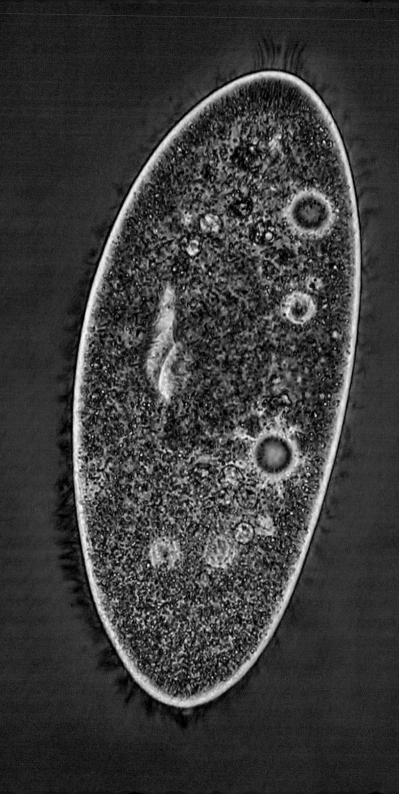

PARAMECIA

The explanation of everything is sought in those [bodies]
which are contained in the microscopic [bodies], and in those
that are in them, and so forth, *ad infinitum.*
> —Leo Tolstoy, *My Religion, On Life, Thoughts*
> *on God, On the Meaning of Life* (1904)

One of the prized possessions in my childhood laboratory was a
microscope, given to me by a friend of the family, a medical man.
With my microscope, I examined the eyes of mosquitoes, hairs from
my head, my own blood. The most startling discovery occurred when
I put a drop of pond water on a glass slide and peered at it through
the lens of my scope. I saw tiny creatures, now greatly magnified,
swimming around, darting this way and that, almost cavorting. There
were bits of plants in the waterdrop as well, and some of the creatures
ate them. Or rather, the shreds of algae seemed to disappear within the
microscopic animals moving about. In that one drop of pond water,
there was a whole enterprising civilization, undoubtedly with its own
predators and prey, reproduction, metabolic cycles, life and death. I
realized that I'd been living with an illusion of scale. An illusion that
the world of houses and forests and fields and people was *the* living
world. But here was an entirely other world, practically invisible to the

naked eye, thriving, quietly going about its business. And all in one drop of pond water.

The first person to observe this micro world was probably the Dutch scientist Antonie van Leeuwenhoek (1632–1723). Van Leeuwenhoek designed and made his own lenses and microscopes. At the time, microscopes and telescopes were new. (The Dutch spectacle maker Zacharias Janssen is credited with building one of the first, if not the first, microscope, around 1600.) In a letter to the Royal Society on September 7, 1674, Leeuwenhoek wrote, "Among these streaks there were besides very many little animalcules. . . . And the motion of most of these animalcules in the water was so swift, and so various upwards, downwards and round about that 'twas wonderful to see: and I judged that some of these little creatures were about a thousand times smaller than the smallest ones I have ever yet seen upon the rind of cheese." In another letter to the Royal Society, he wrote, "I can clearly place before my eye the smallest species of those animalcules concerning which I now write, and can as plainly see them endued with life, as with the naked eye we behold small flies, or gnats sporting in the open air, though these animalcules are more than a million of degrees less than a large grain of sand."

The paramecium was among the first microorganisms to be revealed with a microscope. These "animalcules" range in size from 0.5 to 3.5 hundredths of an inch. They were first named, in 1752, by the British biologist John Hill (1716–1775), adapting the Greek word *paramēkēs*, which means "oblong." They've also been called slipper-shaped.

The paramecium is a single-celled organism. Its insides contain two nuclei, one large and one small, both carrying its full set of DNA. The larger nucleus is where the metabolism of the organism takes place. The smaller maintains stability of reproduction. The organism reproduces mainly by asexual fission, dividing itself into two,

although it can also reproduce by union with another paramecium. In addition to the nuclei, the inside of a paramecium has a number of small compartments, called vacuoles, in which it stores and digests food, bacteria, and algae.

Perhaps the most distinguishing and extraordinary feature of the paramecium are the little hairs protruding from its body, called cilia. These serve two purposes: to sweep food into the organism's gullet and to propel it along. When a paramecium is in motion, its cilia beat like thousands of little oars. Without cilia, paramecia would find it difficult to get from A to B. With cilia, they can swim ten body lengths in a second. That's equivalent to a human running 100 yards in 5.5 seconds, significantly faster than the world record for the 100-yard dash (9.1 seconds). And the average paramecium does that dash many times per day, day after day. Such speed requires a lot of energy. In fact, a paramecium expends half its total energy budget in swimming, comparable to the enormous energy requirements of hummingbirds in hovering.

The development of cilia in microorganisms was a leap in the evolutionary history of life on Earth. The first ciliated organisms appeared about 600 million years ago, at about the same time as the first paramecia. The cilia's rapid motions are powered by proteins called dyneins, which move along microscopic hollow tubes called microtubules, causing them to bend back and forth, producing the waving motion of the cilia.

To better understand these amazing biological motors of the micro-world, consider the figure. Each cilium contains a cylindrical array of fourteen microtubules, each one of which is about 1.5 millionth of a centimeter wide. (The cilium itself is about one-tenth of a thou-sandth of a centimeter wide.) The figure shows one dynein protein attached to two microtubules. In (ii), the dynein detaches from the upper microtubule. In (iii) and (iv), it changes shape and reattaches to the upper microtubule but at a different location, to the right. In (v) and (vi), the dynein protein changes shape again, pulling the upper microtubule to the left. This sliding of the two microtubules relative to each other causes the cilium to bend and constitutes one stroke. The microtubules can make one complete cycle of bending back and forth up to twenty times per second.

All this mechanical motion requires energy, of course, which origi-nates in food and is stored in a molecule called adenosine triphosphate (ATP). The repulsive electrical forces of electrons near one another in the ATP molecule act like compressed springs. When water molecules react with ATP, the compressed springs are released and supply energy very quickly. ATP is found in all plants and animals on Earth and is thought to have evolved with the first terrestrial life-forms, about 3.5 billion years ago.

The paramecium is truly a miraculous phenomenon in the evolu-tion of life on Earth. It is also a reminder that the scale of our human lives is only a narrow slice between the small and the large.

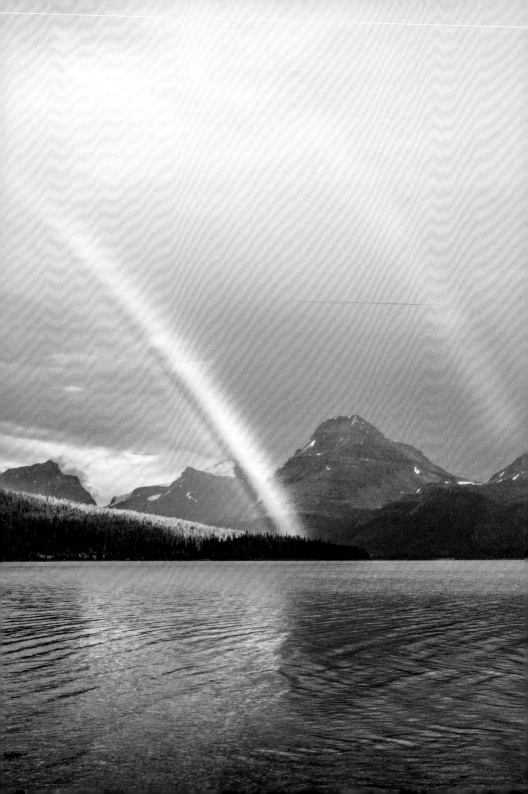

RAINBOWS

Nature always wears the colors of the spirit.
> —Ralph Waldo Emerson,
> "Nature" (1836)

The most memorable rainbow experience I had occurred a few years ago, when my wife and I were kayaking one late afternoon in Maine. A few hours earlier, it had rained. Now, half the sky was dark with heavy clouds and the other half shining with sunlight. Altogether, the light was most eerie, as if we had entered a mystical world. Then we saw the rainbow. The other animals seemed to notice. In that part of the Maine coast, all kinds of birds can be seen flying about: gulls and ospreys and eagles and cormorants and terns, often looking for food. But under the apparition of the rainbow, their flights seemed to change. Birds can actually see more colors than the human eye. My wife and I stopped paddling and simply experienced the extraordinary moment. Then the atmospheric conditions changed and the rainbow melted away.

It's hard to behold a rainbow and not slip under its spell. How does nature produce such magic and majesty? Two things are required: rain and sun. A recent rain leaves droplets of water floating in the air. And the rays of the Sun, which must be behind you to create a rainbow,

strike the water droplets, fan out into colors, and then reflect back toward your eyes. Yes, but . . .

Sunlight, although it appears colorless, actually consists of a range of colors mixed together to make white light. Since the mid-nineteenth century, scientists have known that light is an oscillating wave of electrical and magnetic energy traveling through space. Like waves on a pond, the waves have crests and troughs. The distance between successive crests is called the wavelength. Different colors correspond to different wavelengths. For example, blue light has a short wavelength. It would take about 53,000 wavelengths of blue light to stretch 1 inch. Red light waves are a little longer. It would take only about 36,000 wavelengths of red light to stretch an inch. Sunlight has waves of many different wavelengths, or colors, all scrambled together.

Now we come to the materiality of the world. All materials are made of atoms. Many substances, including water, are made of combinations of atoms called molecules. As discussed in the essay "Morning Mist," each molecule of water consists of two atoms of hydrogen bonded with one atom of oxygen, written as the familiar H_2O. When a wave of light strikes a molecule of water, the energy in the wave is partly absorbed by the molecule, which begins to rotate and vibrate. These vibrations and rotations, in turn, produce their own waves of light. Consequently, when light passes into a droplet of water, we have two sets of light waves: the incoming light waves from the Sun, and the secondary light waves produced by the molecules in the water droplet.

As with colliding ripples in a pond, when different waves overlap, the combined pattern is complex. Under certain conditions, the resulting waves can change direction. How does that happen? Consider for a moment only red light. All the waves have the same wavelength. But we have *two* sets of red light waves, the primary and the secondary.

The secondary waves, produced by the molecules in the water droplet, travel out in all directions, not only in the direction of the incoming (primary) waves. In most directions, the two sets of waves will be out of sync with each other. That is, their crests and troughs won't line up, and they partly cancel each other out, resulting in less light emitted in these directions. But in a particular direction, which depends on both the kinds of atoms and the wavelength of light, the crests and troughs perfectly line up, and the two sets of waves are in sync with each other. The direction of lineup also depends on the angle of incident sunlight relative to the curved surface of the water droplet.

In sum, the light has swerved upon entering the raindrop. Each color, or wavelength, swerves by a different amount. Just as in a prism, the colors in the incoming white light have separated and fanned out. The different colors travel across the raindrop, reflect off its backside, and re-emerge toward the observer. The total change of direction of red light, taking into account the round curve of the surface of the water droplet, is about 138 degrees. The total change of blue light is about 140 degrees.

A series of Persian scientists—Ibn al-Haytham (965–1039), Qutb al-Din al-Shirazi (1236–1311), and his student Kamal al-Din al-Farisi (1267–1319)—understood the basics of rainbows, although not the connection to electrical and magnetic energy and forces. That latter discovery was made by the Scottish physicist James Clerk Maxwell (1831–1879).

There's one more striking aspect of rainbows that cries out for explanation. Why is a rainbow curved? This phenomenon is purely geometrical. Assume that the Sun is low in the sky, so that its rays travel almost parallel to the ground. (If the Sun is not low in the sky, you won't see the full rainbow, and if the Sun is high enough, you won't see a rainbow at all.) Now consider again a single color, say

red light. Sunlight enters the water droplet and, after its colors get separated, the red light emerges at an angle of 180 – 138 = 42 degrees away from the incoming sunlight. Clearly, you see only light reflected back in the direction of your eye. If you are looking at the top of the rainbow, you must look up at an angle of 42 degrees to see the red light.

Now consider looking a bit to the right and at the same altitude as the top of the rainbow. Red light from water droplets in this part of the sky would have to emerge at *more* than 42 degrees from the original sunlight to reach your eyes. But there are no such rays of light re-emerging at that angle. So you don't see anything. However, a bit to the right of the top and at a lower altitude, the angle of the reflected red light striking your eyes is again 42 degrees, and you see the rainbow at this lower altitude. And a bit to the right of that and a bit lower, the angle is again 42 degrees, and so on.

42 degree angle

The situation can be visualized by the illustration above, using a triangular protractor encompassing 42 degrees. Incoming sunlight is parallel to the ground, as shown by the line with arrows. Imagine your eye at the lower left corner of the triangle. As you rotate the triangle,

the angle between the deflected light and your eye is guaranteed to remain at 42 degrees, while the uppermost tip of the triangle moves in a circular arc. That's the arc of the rainbow.

Exactly the same situation applies to the other colors of the rainbow, with slightly different angles.

I must confess that I myself didn't understand exactly why a rainbow is curved, until thinking about it as I wrote this essay.

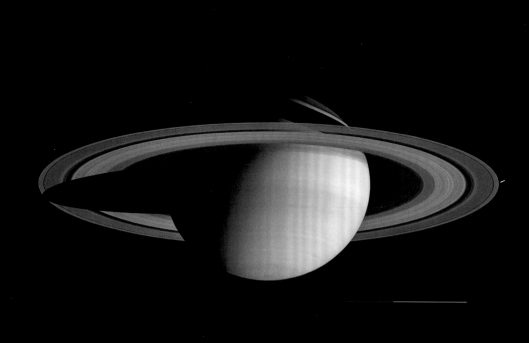

SATURN'S RINGS

When I first saw the rings of Saturn, gazing through a telescope at the Harvard College Observatory, I thought they couldn't be real. One by one, I let my friends take a look. They were equally astonished. The rings are so perfect, so cold and austere and silent. And perfectly circular. How could nature make anything so exact, like the spheres of soap bubbles? And on such a vast scale? It's as if a group of gods were playing a game of toss the ring around the planet, except that nobody missed. Every throw was a dead-on success.

Saturn is not the only planet to have rings. But its set of rings is the largest and most spectacular in our solar system. Some one thousand rings orbit the planet in a disk, with narrow gaps between neighboring rings. The gaps are caused by the gravitational influence of Saturn's 146 moons. And although the rings are about 240,000 miles wide, roughly the distance from Earth to our moon, they are incredibly thin, with a thickness of only about the length of a football field.

Various telescopic observations have revealed that the rings are made out of rocks covered with ice and snowballs, ranging in size from a grain of sand to icy boulders as large as an SUV. Because the rings are so thin, their total mass is only about one-fiftieth of 1 percent the mass of our own moon.

Although there is a bit of controversy, the most widely accepted

theory for the formation of the rings was proposed by the French astronomer and mathematician Édouard Roche (1820–1883). Roche hypothesized that the material in the rings of Saturn originated in a small moon, ripped apart by Saturn's tidal gravitational forces. The strength of gravity between any two bodies increases with decreasing distance between them. On Earth, the gravitational force of the Moon (and Sun) causes ocean tides by pulling on the ocean nearest the Moon with greater force than the part of the ocean farthest from the Moon—in effect producing a stretching apart of the ocean in the direction of the Moon and a bulge on both sides of the Earth, that nearest the Moon and that opposite to it.

Tidal forces can act on solid bodies as well as on liquid. As Roche's hypothesized moon spiraled in toward Saturn, once it got within a few radii from the planet, it would have experienced tidal forces so strong that they would have literally ripped the moon apart. Pieces of the moon formed the rings. The material torn from the parent moon would have continued in the same orbit as the original moon, explaining why the rings all lie in one plane.

We know that our solar system is some 4.5 billion years old, so Saturn's rings were probably created long ago. The process of formation could have taken millions of years. Like many phenomena in astronomy, we cannot know for certain what happened in the distant past. Our understanding of astronomical objects is based on the principles of physics. We test our theories in earthly laboratories and in computer simulations, which have the ability to compress millions and even billions of years into minutes and hours.

Why are the rings perfect circles? Each particle in the rings speeds along its own orbit about Saturn. Any discrepancies between perfect circles would have caused the particles in neighboring rings to collide with one another, producing a kind of friction and altering their

orbits, until all the particles were moving in circular orbits. At that point, neighboring rings would no longer collide, and the friction would be eliminated.

Saturn's rings cannot be seen with the unaided eye. The first person to observe them was Galileo, in 1610, using his own telescope, one of the first to be constructed. However, Galileo's telescope (20x magnification) did not have enough resolving power to discern the structure of the rings or even their separation from the planet. The Dutch scientist Christiaan Huygens (1629–1695) built a better telescope, with a magnification of 43x, and in 1659 described the rings as a disk about Saturn. "[Saturn] is surrounded by a thin, flat ring, nowhere touching, inclined to the ecliptic," Huygens wrote in his book *Systema Saturnium* (1659).

Another natural miracle, of course, is the near perfect roundness of Saturn itself, and of every planet. As discussed in the essay "Bubbles," a ubiquitous precept in physics is the minimum energy principle: Every physical system evolves to a condition of the lowest possible energy available to it. Systems with lower energy are more stable. (There is less extra energy to disturb or change them.) For many systems, a sphere is the shape that minimizes the energy. That holds for soap bubbles and planets.

So why are soap bubbles spherical and rocks not? Soap bubbles are liquid, allowing the molecules of water to move around easily and to find the shape of minimum energy. In solid materials, the molecules cannot move so easily. Here, the story becomes a bit more complicated, and only the most fearless may wish to continue reading.

In objects the size of rocks and larger, there are two main kinds of energy at work: electrical and gravitational. Let's first consider the electrical. Because there are both positive and negative electrical charges, leading to both attractive and repulsive forces, electrical forces

are largely canceled out over distances larger than single atoms. Thus, each group of molecules, composed of atoms, can feel the force of only its nearest neighbors. If the material is liquid, the molecules on the surface can move to a spherical shape, minimizing the total energy. Molecules in a solid structure are tightly bound to one another and cannot move when electrical forces are dominant.

So why are planets, made of solid material, round? Now we come to gravity. Unlike electricity, there is only one kind of charge for gravity, which causes all masses to attract one another. Gravity thus has a long range. As an object gets bigger and bigger, the gravitational forces do not cancel one another out. They get bigger and bigger because every particle in the object is feeling the force of every other particle. For smaller objects, the size of large asteroids and smaller, the total electrical energy is larger than the gravitational energy, and gravity can be ignored. But for bigger objects, like moons and larger, the gravitational energy dominates. It dominates even the electrical forces that hold molecules together in solid materials. And the gravitational energy is minimized for a spherical shape, in which all the particles in the object are as close together as they can get.

The roundness of planets, the circularity of planetary rings, and so many other beautiful phenomena follow naturally from the laws of physics. Which are themselves beautiful.

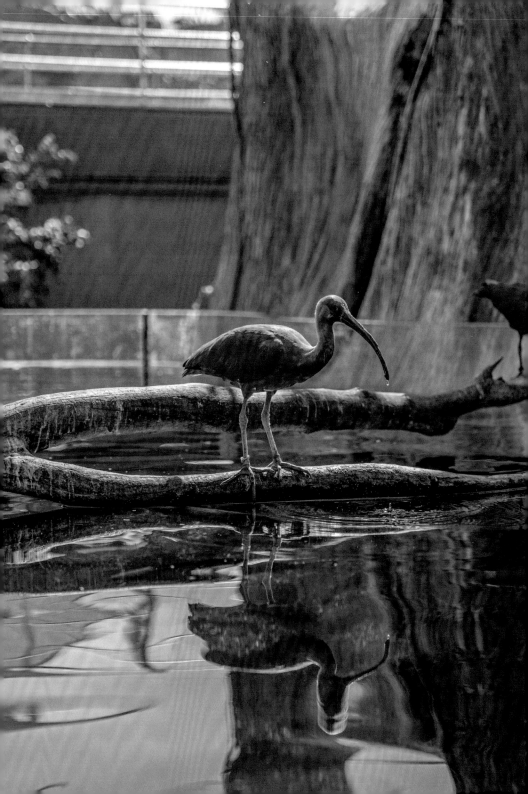

SCARLET IBISES

This past December, my wife and I took our young grandchildren to the Stone Zoo, near Boston. We'd heard intriguing reports about the unusual animals in residence there. Almost immediately after walking in the front gate, we saw a flock of bright reddish-orange birds, like flamingoes, huddled around an artificial pond. Their color was so impossibly loud, their postures so dramatic, that I thought for sure they were part of a plastic installation. After a few moments, however, I saw them move, dipping their long necks into the water in search of food. Mesmerized, we walked through two other gates, until we were within feet of the birds. Even our grandkids were spellbound by the spectacle.

The birds' long thin legs and long thin necks are certainly unusual, but most stunning is their bright color. In fact, the scarlet ibis is the only shorebird in the world with such red coloration. How could nature make a color like that? And why?

There are several standard explanations for bright coloration in animals: to attract mates; as a warning to potential predators; and to blend in with their surroundings, either to avoid being eaten or to provide camouflage while looking for other animals to eat.

Male peacocks, of course, have fabulously colored tails and bodies to entice their intended partners, the bland and brown-colored peahens. According to ornithologists, the brighter the peacock, the more sexy he

is to potential mates. Songbirds, lizards, and many other animals use bright colors for romance.

What about bright colors as warnings? Poison dart frogs come in a fantastic range of oranges, yellows, greens, and blues, with black spots. Their very distinctive appearance signals would-be predators about who and what they are: living containers of a lethal poison, which has been used by native South Americans to tip their blow darts, giving the frogs their name. Coral snakes are brightly colored to broadcast their venomous nature to potential predators. Likewise monarch butterflies. Unless a predator recognizes you, it may eat you before it realizes that you are not so good to eat. So if poison is your survival strategy, it's of survival benefit to be identified from the get-go.

Other survival strategies based on color: The blue oakleaf butterfly looks exactly like a brown, dead leaf on its underside. Owls in a forest are almost invisible. Snow leopards, with light brown fur and black spots, practically disappear amid trees and tall grasses or in rocky mountains.

None of these evolutionary factors seems to apply to the vivid coloration of the scarlet ibis. The males and females are the same color, ruling out mate attraction as a cause of their hue. (Male scarlet ibises have found other ways to attract females: by songs and dances.) The birds are not poisonous or particularly nasty to eat. The snakes, racoons, and large cats that prey on the scarlet ibis do not seem bothered by their bright color. And the birds certainly do not blend in with their environment, unless standing in front of a Mark Rothko painting.

Their color seems to be an accident, resulting from the particular food they eat. Native to South America, the scarlet ibis dines on large quantities of shrimp and other red shellfish, which contain a chemical called astaxanthin. That substance, one of the carotenoids, has a red-orange pigment and is also responsible for giving carrots and tomatoes their reddish-orange color.

There's another kind of ibis, the white ibis, that appears identical to the scarlet ibis except for its color. There is some disagreement among biologists as to whether the two kinds of ibis should be regarded as different species, but they can mate and thus must have a substantial overlap of DNA. While the white ibis does eat crabs and crayfish, its diet is more weighted toward snakes, frogs, and insects. The difference in diets explains the difference in colors of the scarlet and white ibis. Indeed, juvenile scarlet and white ibises have nearly the same colors: a mix of white, brown, and gray.

The difference in diets of the two kinds of ibises is probably an accident—a geographical and environmental separation of ancestors at some time in the distant past. Perhaps one group of those ancestors found itself in a watery habitat with an abundance of shrimp, while the other group found itself in a place with little shrimp but lots of frogs and snakes. While natural selection is a powerful force in determining the traits of different animals, accident plays a big role. In my view, accident is underrated. Even in a material world, following the rules of cause and effect, much of the detailed nature of our cosmos is a result of a chain of accidents. Even as a scientist, I find it a bit comforting to know that not everything in my life is totally predictable.

There's a bit more to the story of the scarlet ibis. The shrimp and red shellfish that form its diet get their own astaxanthin from the algae they eat. And the algae, in turn, produce astaxanthin to neutralize certain harmful molecules called free radicals, which are created by the Sun's ultraviolet rays. In sum, algae make astaxanthin to protect themselves against UV rays; shrimp eat the algae; the scarlet ibises eat the shrimp; my grandchildren and I are dazzled by the color of the birds at the Stone Zoo; and I am moved to sit at my keyboard at this moment, writing this short essay. By accident or not, everything is connected in some way or another.

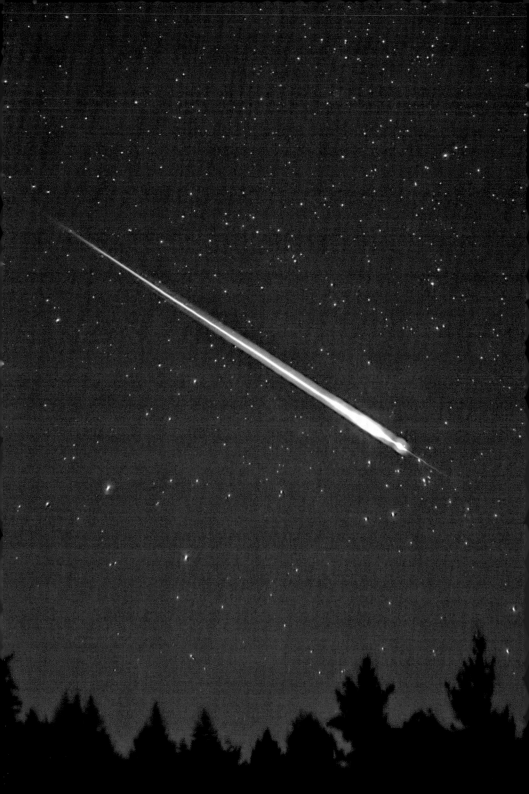

SHOOTING STARS

As I've mentioned before, my wife and I are fortunate enough to spend our summers on a small island in Maine. It's our sanctuary. There are no bridges to the island, no ferry service, and the mainland seems a dim and forgotten ghost far, far away. At night, in the silence, we sit on our dock, looking out over the ocean or up at the night sky, often gleaming with stars. And every August, we are guests at a spectacular show—the Perseid meteor shower. Streaks of light shoot across the sky, sometimes twenty or more in an hour. The sky, normally so peaceful and quiet, throbs and pulses as a living thing. We become aware of our planet as a resident of the universe. It's one of those events, like an eclipse, that gives us a cosmic perspective, often absent as we concern ourselves with dentist appointments and carpools and shopping for the evening meal.

Shooting stars have been seen and recorded by human beings for thousands of years and most often considered as omens, predictions of good things or bad things to come. In one of the earliest records of these spectacular phenomena, engraved on a clay tablet dating back to about 2000 BC, a part of the Babylonian *Enuma Anu Enlil,* the cuneiform characters have been translated to read:

If a shooting star flashes (as bright) as a light or as a torch
from east to west and disappears (on the horizon): the army
of the enemy will be slain in its onslaught.

We now know that shooting stars are pieces of space debris, called
meteors, that intersect the Earth during its orbit around the Sun.
Meteors range in size from less than an inch to several feet across. We
can see most of these with the naked eye. When meteors, traveling at
typical speeds of 100,000 miles per hour, strike the Earth's atmosphere,
they burn up, producing the light we see. That speed is relative to the
Earth. The Earth itself is moving at a speed of 67,000 miles per hour
around the Sun. And the Sun is racing around the center of our galaxy
at a speed of about 500,000 miles per hour. And the galaxy . . . But
that's another story.

Meteors first become visible when they are about 60 miles above sea
level. There's a lot of debris out there in space. Several million meteors
strike the Earth's atmosphere in a single day. The vast majority of them
burn up before they reach the Earth's surface.

The Perseid meteor shower derives its name from the fact that all of
these particular meteors seem to come from a single point in the sky,
radiating from the Perseus constellation. The meteors in the Perseid
shower are cast-off fragments of a comet, Swift-Tuttle, named after
the two American astronomers who discovered it in 1862, Lewis Swift
(1820–1913) and Horace Tuttle (1837–1923). (Analysis of ancient
astronomical records suggests that this comet was probably observed
by the Chinese in 69 BC.) Swift-Tuttle is large as comets go, almost
16 miles in diameter, and, in fact, the largest object to cross the Earth's
path. It has a highly elliptical orbit that is almost perpendicular to the
orbital plane of the Earth and other planets as they move around the

Sun, and it repeats its orbit every 133 years. Swift-Tuttle last visited the inner solar system in 1992.

In general, comets are icy rocks of frozen gases and dust left over from the formation of the solar system about 4.5 billion years ago. As comets approach the Sun and are heated up, some of their frozen material evaporates, leaving a trail of gas and dust in their wakes. In addition, the centers of some comets spin and can fragment. Together, these processes leave various pieces of debris along the path of comets. When the orbit of the Earth passes through that debris, as happens in August with the Perseid meteor shower, we see what we call shooting stars.

What causes the beautiful colors sometimes seen in the tail of a shooting star? Each chemical element and molecule produces a different and distinctive color when heated. (Light is created by electrons in atoms releasing energy as they move to different orbits about the center of the atom; the numbers of electrons and their energy levels are different for each different kind of atom.) As a meteor burns up in its passage through the Earth's atmosphere, each of its vaporized chemical elements glows with a different color. For example, heated calcium produces a violet color, while magnesium, a green or teal color. Nitrogen gives off red light. Sodium yellow. Blue is usually caused by carbon monoxide, a molecule containing carbon and oxygen.

The largest meteor shower ever seen in the United States, before scientists understood the nature and origin of shooting stars, was the Leonid meteor storm, observed in the early morning of November 12 and 13, 1833. People who happened to witness the shower were amazed, as between 50,000 and 150,000 meteors zoomed across the sky each hour. Here is a firsthand account, published in the *Richmond Enquirer* in Richmond, Virginia:

The inhabitants of Charleston, Kauawha C.H., Va., were aroused from their beds, by the ringing of the Church Bell, at half past five in the morning of the 12th inst. Our first sensation was an alarm of fire; but what could equal our surprise and awe, on reaching the door, to find that it was not our village, but the Heavens that were on fire!

The title of the article was "A Wonder in the Heavens!" I am somewhat surprised that people reacted to this strange apparition with awe and wonder, rather than fear, considering that they didn't understand anything about it. Perhaps by 1833, there was enough grasp of science and astronomy in general to eliminate the dread and anxiety that might have been expressed one or two centuries earlier.

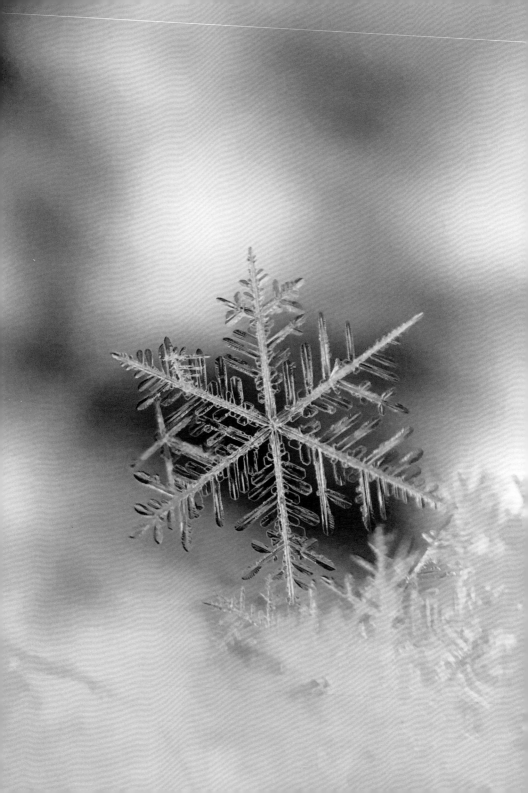

SNOWFLAKES

I do not wonder at a snow-flake, a shell, a summer landscape, or the glory of the stars; but at the necessity of beauty under which the universe lies.

—Ralph Waldo Emerson,
The Conduct of Life (1860)

On a spring day in 1936, shivering in the bitter cold of his laboratory, Dr. Ukichiro Nakaya of Hokkaido University created the first human-made snowflake. The trick, it seems, was a thoroughly dry rabbit's hair. Mounted inside an ingenious container of rising warm water vapor and falling cool air, the hair sprouted ice crystals along its length and got the snowflake started. Up in the clouds, tiny bits of dust serve the same purpose as the hair.

Twenty-seven years later, fully ignorant of my predecessors in snowflake research, I bounded out of doors in a fresh snowfall with my new microscope and spent several hours catching snowflakes on cold glass slides and peering at them under magnification. I was fourteen years old and filled with awe and questions at the same time. How could each snowflake be shaped so differently? Could this variety keep up, with countless trillions of them dropping from the sky? And yet, despite this diversity, every flake had perfect six-sided symmetry,

exactly repeating each fragile branching and vagary six times around. How did a snowflake know to do that?

These questions had been raised before. The German astronomer Johannes Kepler was one of the first observers to document the six-sided symmetry of snowflakes, spelled out and pondered in a little essay of 1611, "A New Year's Gift, or On the Six-Cornered Snowflake." Kepler realized that geometrical truths alone will bring about certain symmetries and regularities when identical objects are packed together. For example, if you stuff golf balls or any identical spheres into a box, two special arrangements maximize the number of balls that will fit: one with four-sided symmetry (squares), and one with six-sided symmetry (hexagons).

In the case of snowflakes, we're not packing spheres together but water molecules. As water freezes into ice crystals, the molecules attach to one another as shown in the figure below:

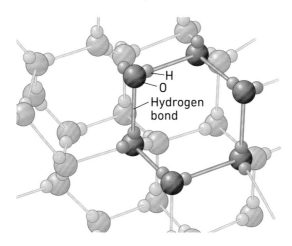

Each water molecule consists of an atom of oxygen, O, and two atoms of hydrogen, H. In the crystal lattice of a snowflake, the hydrogen atoms of each molecule bond to neighboring oxygen atoms, as

shown in the figure and for reasons discussed in some detail in the essay "Morning Mist." When many water molecules are bonded together in an ice crystal, it is not maximum packing that determines the overall configuration, as with the golf balls in the box, but minimum energy. Nature follows the minimum energy principle, described in the essay "Bubbles": systems evolve to a configuration of the lowest possible energy available to them. Such configurations are the most stable and have the strongest balance of forces. Each of the bonds between two water molecules involves a certain amount of energy, dependent on the angle of the bond and the proximity of neighboring molecules. (The bonds themselves are caused by the electrically positive hydrogen atoms attracting the electrically negative nearby oxygen atoms.) For a group of water molecules in an ice crystal, the configuration of minimum energy has six-sided symmetry, as illustrated in the figure. That symmetry, at the core of each snow crystal, where a few thousand molecules are shouldered together, can indeed be explained in terms of the minimum energy principle and the particulars of water molecules.

Each of the six arms emerging from the nucleus of a snow crystal experiences roughly the same environment, so although each arm grows independently of the others, it tends to develop in approximately the same way, translating the small-scale six-sided symmetry to a more global symmetry of the entire snowflake. These symmetries are not perfect but very nearly so as seen by the human eye.

Aside from the ubiquitous six-sided symmetry of snowflakes, what about their endless variety? Snow crystals grow by the condensation of cold water onto a seed of dust or ice, as Nakaya demonstrated almost a century ago. It is also known that the growth pattern depends sensitively on the temperature and humidity of the surrounding air. Aloft for perhaps two hours in its journey to Earth, buffeted by winds in all directions, a growing snowflake lives through a variable and turbulent

history of local weather conditions. Each minute deviation, each different trajectory causes a different montage in the end.

Nature abounds with symmetries: systems that appear the same after some change is made to them. Rotational symmetry, as in the six-sided snowflake, is one such symmetry. Rotate a snowflake by 60 degrees, and it appears identical. But there are other, more abstract symmetries. For example, motional symmetry. As far as the laws of physics are concerned, a system at rest behaves exactly the same way after it is boosted to a constant speed. The two systems are identical. As illustration, if you are sitting in a train at rest in the train station and throw a ball in the air, its trajectory appears exactly the same as when the train is moving at a constant speed. In fact, if you don't look out the window, you can't tell whether your train is at rest or moving at a constant speed. This motional symmetry is the basis for Einstein's theory of relativity.

At the most fundamental level of elementary particles and forces, physicists seeking the laws of nature often try out theories that have a lot of symmetries in their construction. And those theories are usually the ones that turn out to agree with experiment. It seems that nature is pleased by symmetries, just like a fourteen-year-old boy admiring a snowflake.

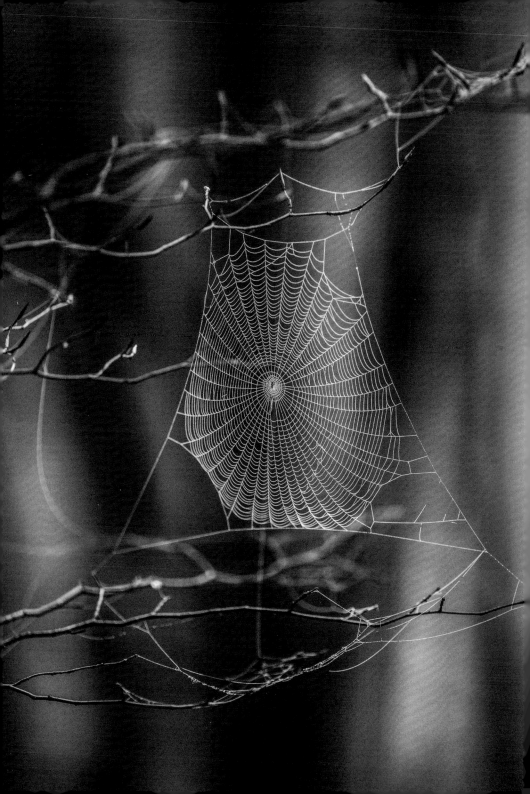

SPIDER WEBS

The spider as an artist
 Has never been employed
Though his surpassing merit
 Is freely certified

<div align="right">

—Emily Dickinson,
Poem 1275 (1873)

</div>

To this writer's eye, the spider web is the most beautiful structure created by any living being other than *Homo sapiens.* My children and grandchildren always stop to marvel at a spider web when they chance upon one. Spider webs are perfect architectural structures, combining functionality with beauty, although I doubt that spiders are motivated by aesthetics.

Spiders are not only artists. They are also engineers. For starters, spider silk has twice the tensile strength of structural steel. For strands of silk and steel with the same thickness, it takes about twice the force to snap the silk as the steel. There are actually more than 45,000 known species of spiders, and they do not all use the same architecture in building their webs. But all are amazing. I'll describe here the creation of the orb web. When this kind of spider spins out its first sticky thread to create a new web, the thread waves around

in air currents until it attaches to a nearby surface. The spider then reels in the thread until it's taut, carefully walks along it to test its strength, and reinforces it with a second thread. The initial "guy line" is augmented by several more, attached to nearby twigs, leaves, and veranda posts. The arachnid then makes a Y-shaped net and spins radial strands around the center. The radials have to be close enough together for the spider to crawl from one to the next. These spiders know what they're doing.

The spider then strengthens the center of the web with four or five new closely spaced radial strands. At first, the spider works from the center outward. After constructing the basic framework, the arachnid then moves from the outer edges inward and lays in more closely spaced threads. These new threads are sticky, helping them trap prey and arise from microscopic droplets of glue suspended on the silk threads. Only recently have scientists understood why spiders don't get stuck in the glue of their own webs. Spiders have tiny branches on their legs that reduce contact as they crawl along their webs, and they also have an antistick chemical on their legs.

The spaces between each strand on the web are proportional to the size of the spider. In effect, the spider uses its own body as a ruler. After the sticky spirals have been built, the spider removes the nonsticky threads, which were used only to rough out the initial structure.

Spiders manufacture their silk from pairs of glands called spinnerets. There are several different kinds of silk, including the adhesive silk mentioned above and a nonadhesive silk used for the initial web structure and also for wrapping up a victim in a deathly cocoon-like structure once the prey is trapped. Spider silk must be strong, but it also must be flexible, without breaking when it is stretched. Scientists know that the material is made of regions of connected chains of proteins for strength, and regions of unconnected proteins for flexibility.

But we still do not know exactly why spider silk is so strong and yet also so flexible.

Spiders are also great tacticians. Webs serve two purposes: offensive and defensive. Sticky webs, of course, trap food in the form of hapless insects that come too close to the web. On the defensive side, webs function as warning signals. When a would-be predator lands on the web, the spider can feel the adversary's presence by vibrations of the silk. Webs are efficient ways to catch food. The spider can simply lie in wait until a victim gets trapped in its web. On the other hand, it takes a lot of energy to create the web. Spiders will sometimes eat part of their own web after it is completed, to replenish their silk and also their expended energy.

Spider webs are not passive structures. One of their most amazing properties, especially for a physicist admirer, is their ability to spring out to grab a victim flying by. This surprising action occurs through electrical attraction. Flying insects often become electrically charged by rubbing electrons off air molecules. The glue on spider silk is electrically conductive. That is, it conducts electricity well and will attract anything electrically charged.

How does that happen? As described in several other essays, each atom consists of a positively charged nucleus and negatively charged electrons orbiting the nucleus. Most atoms are electrically neutral, with an equal amount of positive and negative charge. Certain materials, such as copper and spider silk, are electrically conductive, meaning that each atom of the material has a structure that allows its outer electrons to come unattached from the nucleus and flow from one atom to the next. The atoms are "sharing" electrons. When a positively charged object, like a fly, is nearby, the free electrons in the web's material bunch up as close to it as they can get, causing an attraction. (Negative electrical charges attract positive electrical charges; negative

electrical charges repel negative charges.) When a negatively charged object is nearby, the free electrons move as far away from the object as they can get, leaving the atom more positively charged on the side nearest the object, also causing a net attraction.

Entomologists believe that spiders were among the very earliest animals to emerge from the sea and live on land. The first spiders are thought to have been alive about 400 million years ago. And spiders aren't likely to go extinct anytime soon. They will outlive us all.

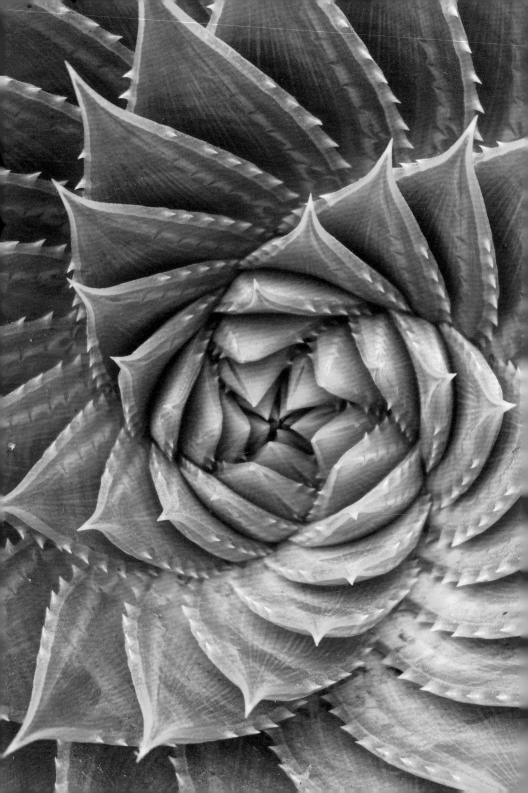

SPIRAL PLANTS

Spiral patterns hold an almost inexplicable fascination. Our eye starts at the center and then winds its way round and round, seemingly going in circles but circles of ever increasing diameter, moving outward and outward and never returning to where we began. We travel on a visual voyage, always staying close to where we've been. Spirals are made for the timid traveler, wanting adventure but not too much adventure.

Spirals have intrigued human beings for thousands of years. One of the oldest is the "Triple Spiral" in the Newgrange passage tomb in County Meath, Ireland, dating back to around 3200 BC—before Stonehenge, before the Great Pyramids of Giza. The meaning of these triple spirals is not known, but since they were found in a tomb, they probably had some sacred or religious significance, such as representing birth, life, and the afterlife.

Spirals are also found in pre-Columbian art in Latin America. The spiral is an ancient symbol of evolution.

Many growing things, such as the *Aloe polyphylla*, the seed heads of sunflowers, the seed pods of pinecones, and shells of the chambered nautilus, exhibit a particular kind of spiral pattern in which the length of each quarter turn of the spiral equals the sum of the lengths of the two previous quarter turns. We will call this a Fibonacci spiral, for reasons to be revealed in a moment.

Why is such a pattern so ubiquitous? It's probably due to the minimum energy principle discussed in the essay "Bubbles." Physical systems take the shape that requires the minimum energy. And when given options, nature often chooses to accomplish its tasks with the minimum expenditure of energy.

In 2004, two mathematicians at the University of Arizona in Tucson, Patrick Shipman and Alan Newell, published a paper titled "Phyllotactic Patterns on Plants," which suggests that nature was following the minimum energy principle when making Fibonacci spirals. The mathematicians calculated the stresses on the tips of plants as they grow and the cells divide. The stresses cause the leaves of certain plants to bend around, producing a spiral-like growth. The mathematicians found that the energy of these stresses is minimized when the spiral takes the form of the Fibonacci spiral.

Now we enter the kingdom of magic. The twelfth-century Italian mathematician Leonardo Pisano Fibonacci (1170–1240) discovered an interesting sequence of numbers that we now call the Fibonacci series:

0, 1, 1, 2, 3, 5, 8, 13, 21, 34, 55 . . .

Each number in the series, after the first, is the sum of the two previous numbers. And if we construct a spiral made of the quarter

circles connecting the opposite corners of a series of ever bigger squares whose sides are the numbers in the Fibonacci series, we get the same spiral found in the *Aloe polyphylla*, the seed heads of sunflowers, the seed pods of pinecones, and shells of the chambered nautilus.

There's even more to this natural magic. Biologists, architects, psychologists, and anthropologists have long noted that we humans find especially pleasing those rectangles whose ratio of long side to short side is approximately 3/2. That ratio is close to what is called the golden ratio, sometimes called the golden mean. Two numbers are in the golden ratio if the ratio of the larger number to the smaller is the same as the ratio of their sum to the larger number. In mathematical terms, if a is the larger number and b the smaller, then $a / b = (a + b) / a$.

From this seemingly simple definition, we can determine that the golden ratio is 1.61803 . . . As you can test for yourself, the ratio of a number in the Fibonacci sequence to the one before it approaches the golden ratio as we go to bigger and bigger numbers. For example, 21/13 = 1.615, 34/21 = 1.619, and 55/34 = 1.618. So this special series of numbers, manifested in the spiral patterns of plants and shells, is also closely related to the golden ratio, a set of proportions we humans find aesthetically pleasing. It's not that surprising that we human beings are

drawn to such proportions and their related spirals. They are part of nature, and we are part of nature. And the structures we build share that aesthetic.

With all of these surprising relationships, my understanding of the material and mathematical underpinnings of nature does not in the least diminish my amazement of those phenomena. In fact, such understanding enhances my pleasure. For me, the elegance of the mathematics of the Fibonacci series, the presence of that particular beauty in seashells and plants, and my own biological affinity for such beauty are all of a piece, a wholeness, a profound connectedness of all living things. We are part of a whole.

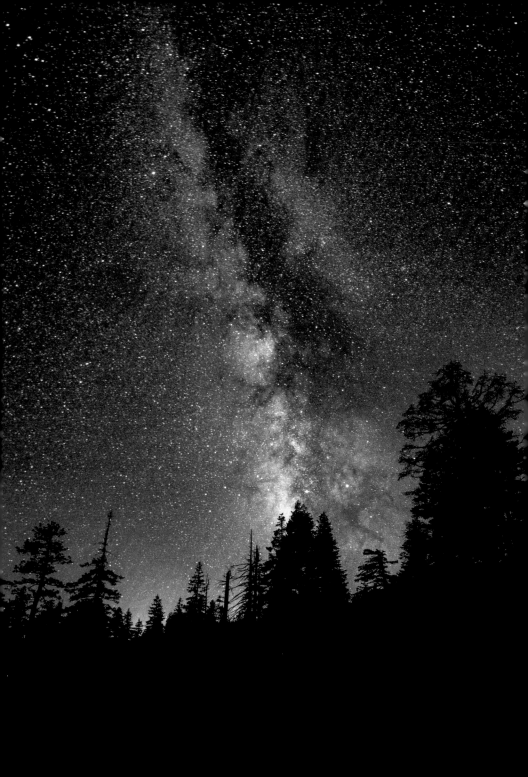

STARS

Does not the heaven arch itself there above—Lies not the
earth firm here below?—And do not eternal stars rise, kindly
twinkling, on high?

—Goethe,
Faust (1832)

Walking outside on a clear, dark night and looking up at the sky is an
experience like no other—transcending time and space, our bodies,
even our sense of self. We feel like we are falling into infinity.

For all of recorded human history, and almost certainly long before
that, the stars have represented perfection, eternity, immortality, the
divine. Ancient Egyptian stone texts, discovered in the pyramid of
Unas, dating back to about 2315 BC, suggested that the dead pha-
raohs would enter heaven through two bright northern stars known as
ikhemu-sek, "the indestructibles." Evidently, the perceived permanence
of the stars was linked to human immortality, or at least the human
desire for immortality. Plato was less elitist. He chose the stars to be
the final destination of *all* moral human beings after their fleeting
sojourn on Earth: "And having made [the universe] he divided the
whole mixture into souls equal in number to the stars, and assigned
each soul to a star. . . . He who lived well during his appointed time

was to return and dwell in his native star." Here, the first "he" is the "creator of the universe."

As discussed in the essay "Galaxies," we know today that stars are spheres of hot gas, mainly hydrogen and helium. The inward pull of gravity is balanced by an outward force of thermal pressure. That outward force is created by heat generated in nuclear reactions at the center of stars. For smaller objects, like planets, the inward force of gravity is balanced by the electrical forces in solid matter, resisting compression. But in objects as big as stars, those solid state electrical forces are not sufficient to counterbalance gravity.

Aristotle and many thinkers up to the seventeenth century believed that the stars and other heavenly bodies were composed of a perfect, unchanging, indestructible substance called aether—very different from the ordinary stuff making up Earth. Such a substance would confer eternity to stars. Then, in 1610, using his new telescope, the Italian scientist Galileo observed craters on the Moon and spots on the Sun. He concluded that the Sun, Moon, and planets were not unblemished and thus could not be made of a perfect substance.

The idea that stars might be suns had recently been proposed by the Italian philosopher and writer Giordano Bruno (1548–1600). In his *On the Infinite Universe and Worlds* (1584), Bruno wrote that "there can be an infinite number of other worlds [earths] with similar conditions, infinite suns or flames with similar nature." (For his astronomical proposals as well as his denial of other Catholic beliefs, Bruno was burned at the stake in 1600.) Thus, when Galileo reported blemishes on the Sun, his findings had dramatic implications for all the stars. The stars could no longer be considered perfect things, composed of some eternal and indestructible substance unlike anything on Earth. In the 1800s, astronomers began analyzing the chemical composition of stars by splitting their light into different wavelengths with prisms.

Different colors could be associated with different chemical elements emitting the light. And stars were found to contain hydrogen and helium and oxygen and silicon and many of the other common terrestrial elements. Stars were simply material.

It was Isaac Newton who first managed to estimate the distance to nearby stars. If one assumes that stars are similar things as our sun, Newton asked, how far away would our sun have to be in order to appear as faint as nearby stars? The challenge in such a calculation is how to compare the brightness of our sun to that of a star. In the mid-seventeenth century, Newton didn't have electronic photocells at his disposal. He did, however, know that at certain times of the year the planet Saturn appears about as bright as a bright star. That planet glows because of reflected light from the Sun. Figuring out the fraction of the Sun's light Saturn intercepts, Newton was able to get his answer: about 25 million million miles to the closest stars.

How do the Sun and other stars get their enormous energy? In the nineteenth and early twentieth centuries, various theories were proposed: (1) the heat energy contained within the material of the star, (2) the chemical energy in the star's material, similar to the chemical energy in explosives like TNT, and (3) the gravitational energy released by slow contraction of the star. However, none of these sources of energy were nearly strong enough to account for the observed luminosities. In 1913, using radioactive dating techniques (see the essay "Ha Long Bay"), scientists knew that the Earth, and hence the Sun, was at least 1.6 billion years old. But chemical, thermal, and gravitational energy could make the Sun shine for only about 20 or 30 million years at most.

Then nuclear energy was discovered, mainly through the work of Ernest Rutherford and Francis William Aston (1877–1945). Pound for pound, nuclear is a hundred thousand times more powerful than

chemical energy. In 1920, British astrophysicist Arthur Eddington (1882–1944) proposed that nuclear energy was the magical powerhouse at the center of stars. As he wrote in a landmark paper titled "The Internal Constitution of the Stars," published in *Nature* magazine, "If 5 per cent of a star's mass consists initially of hydrogen atoms, which are gradually being combined to form more complex elements, the total heat liberated will more than suffice for our demands, and we need look no further for the source of a star's energy."

But even nuclear energy cannot make a star last forever. Nuclear fusion releases energy when small atoms combine together. For example, when four atoms of hydrogen, the smallest atom, join to make an atom of helium, energy is released. But fusion does not produce energy for large atoms (because of the increasing dominance of repulsive electrical forces, which overwhelm the attractive nuclear forces and push the subatomic particles apart).

Our sun will continue producing energy by nuclear fusion for another 5 billion years or so. At that point, the atoms from previous fusions will be so large that their continued fusion will not produce any more energy. Without the heat and outward pressure to counterbalance gravity, our sun will collapse and eventually form a compact and dim sphere called a white dwarf, about the same diameter as the Earth. Stars with masses ten times the mass of our sun or larger have a different fate. They end their life in a violent explosion called a supernova. Much of the material of a supernova explosion is spewed out into space, but an extremely dense remnant remains, a neutron star, which has the mass of our sun contained within a sphere about 10 miles in diameter. One thimbleful of neutron-star material would weigh as much as a several hundred million elephants. Eventually, every star in every galaxy will burn out or explode, leaving cold and

dim white dwarfs and neutron stars. We know all these things from a combination of theoretical calculations and telescopic observations.

Understanding the nature of stars, after millennia of myths and speculations, is another testament to the power of the human mind and the step-by-step progress of science to fathom the world.

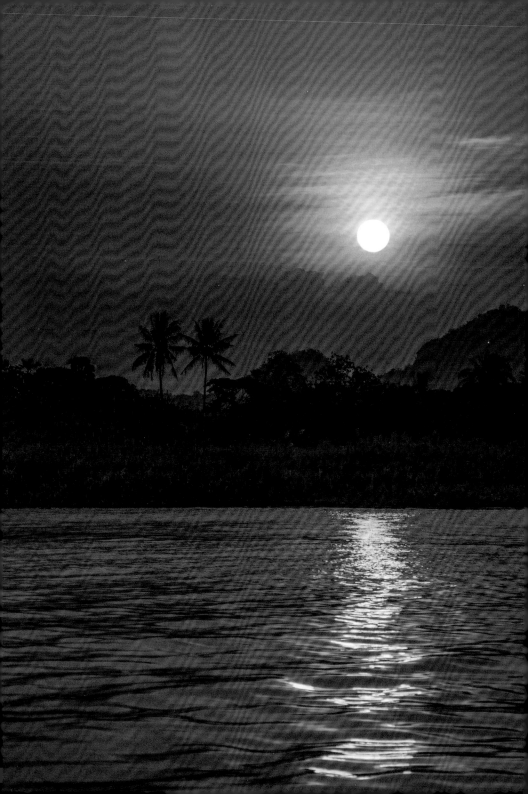

SUNSETS

She sweeps with many colored Brooms—
And leaves the shreds behind—
Oh Housewife in the Evening West—
Come back and dust the Pond!

You dropped a Purple Ravelling in—
You dropped an Amber thread—
And now you've littered all the East
With Duds of Emeralds!

<div style="text-align:right">

—Emily Dickinson,
Poem 219 (1861)

</div>

Throughout the centuries and millennia, people proposed many theories for the Sun and its light. The ancient Greeks had a story involving the Hesperides, the goddesses of the evening. The Hesperides were keepers of the tree of golden apples, which was given to the goddess Hera on her wedding day. The four nymphs and their golden-red apples were thought to be the source of the reddish light at sunset. The Hesperides had the names Aigle, Hesperis (meaning "sunset glow"), Erytheia, and Arethusa.

Sunsets have always conveyed a sense of calm and peace, their colors much warmer and gentler than the harsh light of the daytime Sun.

Why does the setting Sun paint the sky red in its direction? As discussed in the essay "Rainbows," sunlight consists of waves of energy, with many different wavelengths all jumbled together. Each of those wavelengths stimulates particular receptor cells in the eye, causing what we experience as a different color. When the wavelengths are mixed together, as in sunlight, all the receptor cells in the eye are stimulated, and we have the sensation of colorless white light. When wavelengths in only a narrow range reach the eye, then only some of the receptor cells are stimulated and, depending on which cells, we experience a sensation we name blue light or red light, and so forth.

Also discussed in the essay "Rainbows," when a wave of light strikes any material such as air, it causes the molecules in that material to rotate and vibrate, and those movements produce secondary waves of light that travel out in all directions. For reasons that would require some mathematics and physics to explain, shorter wavelengths of incoming light react with the molecules in air much more strongly than longer wavelengths. In other words, shorter wavelengths are absorbed by the air more easily and re-emitted in the secondary beam more easily. Consequently, much of the energy in the shorter wavelengths is transferred to the secondary waves, traveling out in all directions, whereas much of the energy in the longer wavelengths remains in the original sunlight and continues to travel in its original direction.

Indeed, the shorter wavelengths of light, toward the blue end of the spectrum, after striking the upper atmosphere and being redirected in secondary waves, then strike other air molecules and are redirected once again. This process continues to tertiary waves and so on. That's why the daytime sky appears blue, even when we look away from the Sun. We are seeing sunlight that has been redirected, or "scattered,"

many times. Only the shortest wavelengths of light, at the blue end of the spectrum, interact strongly enough with the air's electrons for such numerous redirections.

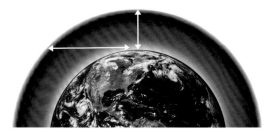

As can be seen in the above figure, when the Sun is low in the sky, there's a larger layer of air between us and the Sun than when the Sun is high in the sky. In the former case, all the blue light has been scattered out of the direct sunlight. But the red light, at longer wavelengths, remains. It has interacted more weakly with the intervening air and travels unimpeded in its original direction, from the Sun to our eyes. That's why the sky in the direction of the setting Sun appears red. Here is a case where the weak win out.

In many ancient cultures, the Sun god was the principal deity. In ancient Egypt, his name was Ra. Each day, Ra traveled across the sky in his sun boat. And each day was a rebirth. At dawn, Ra was a newborn. During the morning, he was a child. In the middle of the day, he was in the middle of his life. And at sunset, he was an old man, about to die and enter the underworld of darkness.

The oldest cultures for which we have records are the Sumerians and Akkadians, dating back to about 4000 BC. The Sumerian sun god was called Utu, who rode across the sky in a chariot pulled by four animals, which were probably lions or horses. Sunrise and sunset were thought to be events when Utu traveled through heavenly gates situated on mountains on the opposite sides of the world.

VOLCANOES

On June 3, 1866, humorist Mark Twain witnessed an eruption of the Kīlauea volcano, in the Hawaiian Islands. His description:

> Through the glasses, the little fountains scattered about looked very beautiful. They boiled, and coughed, and spluttered, and discharged sprays of stringy red fire—of about the consistency of mush, for instance—from ten to fifteen feet into the air, along with a shower of brilliant white sparks—a quaint and unnatural mingling of gouts of blood and snow flakes! . . . I forgot to say that the noise made by the bubbling lava is not great, as we heard it from our lofty perch. It makes three distinct sounds— a rushing, a hissing, and a coughing or puffing sound.

Geologists believe that volcanoes are formed when a massive slab of rock in the Earth's crust slides underneath another massive slab of rock. Most of the Earth's surface is covered by seven such slabs of rock called tectonic plates and another eight or so minor plates. The seven major plates include the African, Antarctic, Eurasian, North American, South American, Indo-Australian, and Pacific Plates. Some of the minor plates include the Arabian, Caribbean, Nazca, and Scotia

Plates. Tectonic plates shift and move when they are disturbed by flows of molten rock beneath them, and by gravitational forces.

There are about 1,500 active volcanoes on our planet, and the Kīlauea volcano is the most active of all. It's between 210,000 and 280,000 years old and emerged above sea level about 100,000 years ago. Its most recent outburst began on September 10, 2023.

Where does a volcano get its enormous heat, and what causes it to erupt? To answer the first question, we need to go back to the formation of the Earth, about 4.5 billion years ago. As described in the essay "Fall Foliage," scientists have much evidence that the Earth and other planets condensed out of a rotating mass of gas and solids. Although most of this material was revolving about the infant Sun in the same direction, some of it had random motions that did not follow the overall pattern, and there were collisions involving this wayward material. According to the best theory, one such collision between the primordial Earth and a small planet ripped off solid material that became our moon.

These proto-planetary collisions in the early solar system released a huge amount of energy. (Imagine two gigantic trucks traveling at high speed and then ramming into each other in a head-on collision.) That energy heated up the colliding material to temperatures of 5,000 – 10,000 degrees Fahrenheit or higher and melted it. As the material forming the Earth began to condense into a sphere, gravitational energy was released, further heating that material.

At temperatures above 2,000 degrees Fahrenheit, rocks melt and turn into a molten liquid called magma. The outer parts of the molten Earth were able to cool rapidly, but not the deep interior, which would be thermally insulated by the outer regions. Indeed, the central regions of the Earth are still extremely hot and consist mainly of molten iron and nickel. These metals, present in the proto-planetary

cloud, are much denser than ordinary rock. Consequently, they sank to the center of the Earth. The center of the Earth today remains at a temperature of about 9,400 degrees Fahrenheit and a pressure of about 3.6 million times atmospheric pressure.

The other source of heat in the Earth's interior is radioactivity. Radioactive uranium and thorium, also present in the initial cloud of material, are even more dense than iron and nickel. Thus they also sank to the center. Their radioactivity, which is the disintegration of atoms by the emission of high-speed subatomic particles, continues to heat the magma in the Earth's interior.

Several factors trigger a volcanic eruption. Liquids are generally less dense than solids, and molten magma is less dense than the surrounding solid rock. So the magma rises upward due to buoyancy forces. There is also upward pressure derived from gases dissolved in the magma. Thirdly, new magma is constantly being produced by the heat in the Earth's interior. When the upward pressure of the magma becomes great enough, it creates an opening or vent in the Earth's surface and pours out. The volcano has erupted.

Some volcanic eruptions can create lightning. (See the essay "Lightning.") Here the buildup of electrical charge responsible for lightning is caused by the friction between colliding particles of volcanic ash, transferring electrons from one bit of material to another (a form of static electricity). The earliest recording of volcanic lightning was from Pliny the Younger (61–113 AD), a lawyer and magistrate of ancient Rome. Pliny witnessed the famous eruption of Mount Vesuvius in 79 AD. In a letter to the Roman historian Tacitus, he wrote:

The cloud could best be described as more like an umbrella pine than any other tree, because it rose high up in a kind of trunk and then divided into branches. . . . The ash already falling

became hotter and thicker as the ships approached the coast, and it was soon superseded by pumice and blackened burnt stones shattered by the fire. . . . A dreadful black cloud was torn by gushing flames and great tounges of fire like much-magnified lightning.

Volcanoes are common in our solar system and occur on other planets and moons. The largest of those is called Olympus Mons, on Mars, a fairly young volcano that is thought to be still active. It is about 375 miles wide, the size of Arizona. It was observed and measured by the Mars Orbiter Laser Altimeter, an instrument aboard the *Mars Global Surveyor* spacecraft, which orbited Mars and broadcast data from 1997 to 2006.

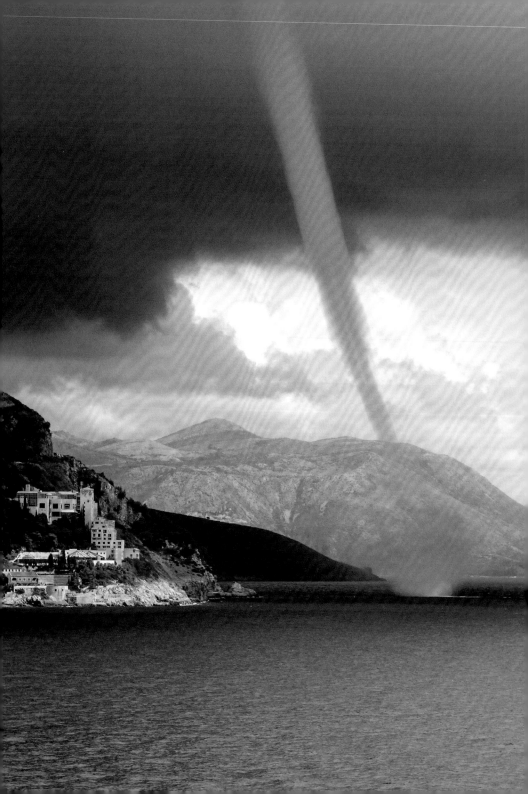

WATERSPOUTS

For our honeymoon, my wife and I chartered a small sailboat in the Greek isles. It was just the two of us. For the first few days of the voyage, traveling south along the coast from Piraeus to Cape Sounion, we were within sight of land. Then we turned west, toward Hydra. Soon, the land and other boats vanished. All we could see was ocean. At one point, off in the distance, we spotted a strange sight. A curving funnel arced down from the sky and plunged into the water. And we could hear it. It sounded like a heavy rain, coming largely from swirling wind. Of course, we were frightened by this dramatic show of force by Mother Nature, possibly able to suck up our boat and rip it to splinters. But we were also in awe of this remarkable natural phenomenon.

A waterspout is essentially moisture-laden wind, rapidly rotating in a tight circle. Typical diameters are about 150 feet, and typical wind speeds about 50 miles per hour. There are two kinds of waterspouts—those that occur in clear air, and those that are associated with thunderstorms, essentially tornadoes that touch down over the ocean rather than the land. I'll consider the second kind here.

Tornadoes and waterspouts generally require updrafts of moist warm air. Air is moistened by bodies of water, and it is warmed by the ground, which is heated by the Sun. Warm air naturally rises because

the molecules are moving faster than those of cold air, sending them farther apart and lowering the density. Thus a cubic foot of cold air is heavier than a cubic foot of warm air and sinks down through it, pushing the warm air upward. That's called buoyancy.

The rising warm air has two consequences. The water vapor in it condenses into liquid water when it meets cold air. That's why tornadoes are usually associated with thunderstorms and clouds. Second, the rising columns of warm air tilt the spinning wind of a tornado from horizontal to vertical, as shown in the illustration.

The principal cause behind most weather phenomena is uneven heating of the Earth by the Sun. Another important factor is the rotation of the Earth, which affects large-scale weather patterns. Beyond that, weather and its origins quickly become complicated.

What causes wind? What causes the spinning of a waterspout, its most distinctive feature?

In general, wind results from air pressure differences, with air pushed from high pressure areas to low pressure areas. Differences in air pressure, in turn, are caused by uneven heating of the Earth by the Sun. The equatorial regions of the Earth receive more direct sunlight than the polar regions, causing the former to be warmer. More locally,

the ground can often be warmer than the ocean, affecting the air above these regions. Temperature variations of air, which affect the random speeds of air molecules, produce pressure variations.

Now we come to the spin of the tornado or waterspout. Spin is produced when different columns of wind are moving in different directions and at different speeds, a phenomenon called wind shear. The speed of wind generally increases with altitude. Wind at lower altitudes is slowed by friction with the ground. At higher altitudes that friction decreases. Temperature variations at different heights also increase wind speed at higher altitudes.

Second, the spin of a tornado or waterspout is connected to the movement of the larger storm system that produces it. And that movement is affected by the rotation of the Earth, in a phenomenon called the Coriolis effect. Wind or any freely moving object not acted on by outside forces travels in a straight line (Newton's first law). But when viewed from a rotating frame of reference, the object appears to move in a curved trajectory. As a familiar illustration, if you stand on a merry-go-round and roll a marble across its floor, the marble will appear to travel in a curved path. That's because you are rotating. The marble is actually traveling in a nearly straight line as seen by someone not on the merry-go-round. The Earth is like a giant slowly rotating merry-go-round. Thus when wind travels by, it appears to be deflected into curved path. As a result of this Coriolis effect, almost all storm systems in the Northern Hemisphere rotate in a counterclockwise direction, and almost all in the Southern Hemisphere in a clockwise direction—caused by the rotation of the Earth. Tornadoes and waterspouts take their spin, or rotation, from these larger storm systems.

All in all, the science behind waterspouts and tornadoes is rather

complicated. There are lots of variables, and slight changes in some of them can cause large effects, making it extremely difficult to predict when such extreme weather will occur.

Since at least 1950, the states of Texas, Mississippi, and Kansas share the honor of having experienced the largest number of tornadoes. Of course, the most famous tornado in Kansas was the one that transported Dorothy to the magical land of Oz, in *The Wizard of Oz*.

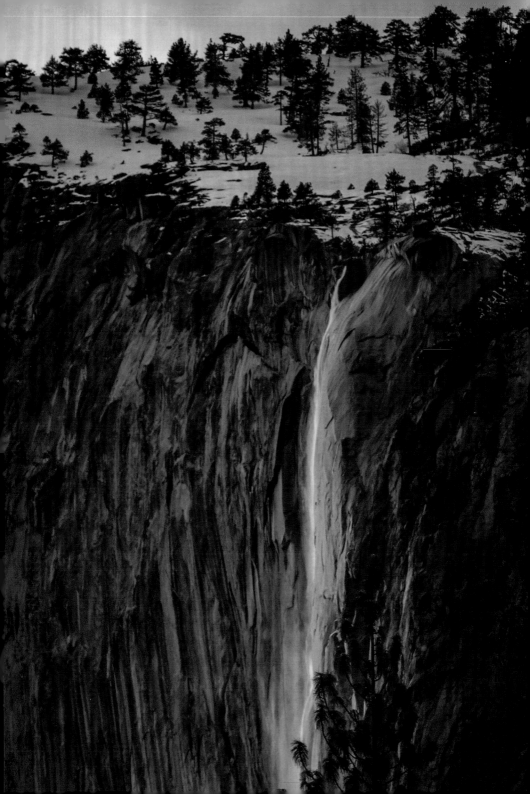

YOSEMITE FIREFALL

When the short day is brightest, with frost and fire,
The brief sun flames the ice, on pond and ditches.

—T. S. Eliot,
"Little Gidding" (1942)

When I was a graduate student in California, in the 1970s, I went camping in Yosemite National Park, a preserve of over a thousand square miles of meadows, glaciers, mountains, lakes and streams, waterfalls, granite cliffs, and giant sequoia trees. I remember a section of Yosemite called Tuolumne Meadows, about 8,500 feet in elevation. It was a vast, grassy field, surrounded by snow-covered mountains. As I recall, my friends and I drove to a parking lot and then hiked for several miles to get to the meadows. Each of us had our own tent. Mine was orange, with a netted front flap to let in passing breezes during hot weather. Early in the mornings, we were awakened by the songs of kingfishers, goldfinches, meadowlarks, and cinnamon teals, which sounded like ducks. The air smelled of fresh strawberries. It was a sacred place, a place of stillness, and back then you could hike for miles without seeing more than a few people.

The most spectacular sight of Yosemite, I didn't see in those years. It is Horsetail Fall, which flows over the eastern edge of the El Capitan

rock formation and drops almost half a mile to the valley below. The water flows only during the winter, when there has been enough snow-melt to feed it. In the second week of February, if the temperatures have been warm enough during the day to melt the snowpack, and if the western sky is clear at sunset, for about 10 minutes the angle of the Sun hitting the waterfall is just right to make it light up bloodred. The waterfall transforms into something that looks like molten lava being poured over the cliff. It's a strange and beautiful spectacle: burning lava spilling down from a snow-covered mountaintop. It's natural magic.

As discussed in the essay "Sunsets," sunlight consists of many colors mixed together. As sunlight hits the Earth's atmosphere, the blue colors get scattered by air molecules more than the red colors. When the Sun is low in the sky, as at sunset, there is a larger amount of atmosphere that the sunlight must traverse in getting to the eye of an observer, and all the blue gets scattered out of the direct beam, leaving only red light. That's why the waterfall glows red. Although the scene is spectacular, the science behind it is rather simple, as if a magician revealed the thin black wires causing an assistant to appear to float in the air. But knowing the material causes, for me, does not in the slightest diminish the amazement and majesty of the spectacle.

The brevity of Yosemite's Firefall is one of its most striking marvels. Would the display be quite so fascinating and beautiful if it lasted hours, or days? Similar in the fleeting nature of its appearance is the "green flash," a green spot sometimes seen for mere seconds on the upper edge of the Sun just as it disappears below the horizon. Or the occasional shooting star, a rock from outer space that catches on fire when it hits the Earth's atmosphere and can be seen for just a few seconds on a clear night.

Some of nature's most spectacular phenomena last only moments. Thinking of these things leads me to muse on our human perceptions

of time. On what basis do we consider a duration long or short? A few seconds is a fantastically long time compared to most of the invisible molecular processes in the body, but a very short time compared to one rotation of the Earth about its axis. Since we're talking about human perceptions, perhaps the smallest unit of perceived time should be a conscious moment, the shortest period of time in which we can have a conscious thought. That's about half a second, governed by the time for a large number of neurons in the brain to communicate with one another. The longest period of time for which we are conscious is clearly a human lifetime, roughly seventy-five years. So "long" and "short" perceptions of time must be wedged between these two extremes. Since our daily human activities, including waking and sleeping cycles, are regulated by the length of the day, I would suggest that most phenomena seem short-lived if their duration is much shorter than a fraction of a day, say a few hours. In this sense, the 10-minute spectacle of the Yosemite Firefall is truly short.

All of these considerations remind me that beauty and wonder are "in the eyes of the beholder." And that beholder is we *Homo sapiens,* with our particular physical and psychological machinery. Would alien beings consider the Yosemite Firefall beautiful? Or spider webs? Or Saturn's rings? Or hummingbirds? For a few moments, I ponder abstract questions. And then I put them aside and simply experience the majesty and awe of the phenomenon.

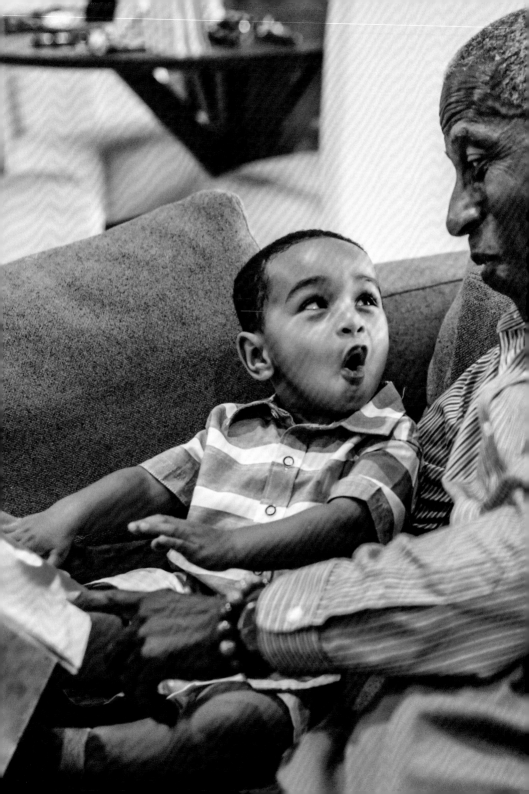

HUMANS

Spider webs and galaxies. Fireflies and volcanoes and hummingbirds. Mammatus clouds. Of all the extraordinary phenomena of nature, none are more amazing than us human beings. Look at what we've created. The Great Pyramid of Giza. Beethoven's Ninth Symphony. The *Mona Lisa. Romance of the Three Kingdoms. Macbeth. The Ramayana.* London. Paris. Singapore. The theory of relativity. Antibiotics. Computers . . .

"Amazing" might not be applied to our physical appearance. An intelligent alien from outer space might not deem our looks all that interesting. But if he/she/it saw the Great Pyramid of Giza or listened to Beethoven's Ninth or dropped in on our cities . . . they might have a different opinion.

And from whence come these exquisite inventions? From our brains. We have a substantially larger brain than any other earthly animal of our body weight. What is most extraordinary about us human beings cannot be seen from the outside. From the outside, it's invisible. Yet that 3 pounds of spongy mass hidden within our skulls, with its 100 billion neurons each connected to several thousand other neurons, is capable of thinking, of understanding the relativistic nature of time, of composing symphonies and poetry, of building cities, of falling in love.

Certainly other animals show manifestations of love. But what other animals could write these lines?

How do I love thee? Let me count the ways.
I love thee to the depth and breadth and height
My soul can reach, when feeling out of sight
For the ends of being and ideal grace.
I love thee to the level of every day's
Most quiet need, by sun and candle-light.

What other animals have figured out how the universe began, deriving and verifying the cosmological equations

$$\left(\frac{\frac{dR}{dt}}{R}\right)^2 = \frac{8\pi\rho}{3} - \frac{k}{R^2} + \frac{\Lambda}{3}$$

that describe quantitatively how the scale of the universe (R) changes in time (dR/dt) under the influence of the density of matter (ρ) and dark energy (Λ)? What other animals have been able to decode the animal-building instructions found in each living cell?

I cannot come close to describing or even understanding all the features of us human beings, so I'll just say a few words about our brains. I would argue that our human brains are the most complex known objects in the universe—vastly more complex than volcanoes, or black holes, or galaxies. And the most spectacular activity of our brains is that fundamental mental sensation we call consciousness: the feeling of "I-ness"; the first-person participation in the world; the awareness of self; the sense of being a separate entity in the world; the simultaneous reception and *witnessing* of visual images, sound,

touch, memory; thought; the ability to conceive of the future and plan for that future.

The sensation of consciousness remains mysterious. Although scientists believe that the sensation is ultimately rooted in the material neurons in our brains and the electrical and chemical signals between them, we're still a long way from filling in all the blanks leading from those neurons to the unique mental experience we call consciousness. Indeed, some philosophers believe that we'll never be able to fill in all the blanks, that there is an unbridgeable gap between the first-person subjective experience of consciousness and the third-person objective nature of neurons and the atoms they're made of. Such a view is expressed by the philosopher Thomas Nagel in his landmark article "What Is It Like to Be a Bat?" published in 1974. Essentially, Nagel argues that we can never know what another organism feels, whether a bat or an advanced AI system. A related viewpoint is found in the philosophical argument known as "Mary's Room" (1982), in which Mary, a scientist, has lived her life in a black-and-white room and knows everything about color in scientific terms. But the actual experience of color, when she goes out of her room, is completely new and different.

The experience of consciousness, at least at its higher levels, is the first-person subjective par excellence. The analysis of 3 pounds of neurons sitting on the lab table, the probing of that brain with instruments, the measuring of its electrical quiverings, the writing of equations to describe it, even the mere talking about it as a *thing*—are all third-person activities. But the sensation of *being* is first person. We can't be inside the box and outside the box at the same time. Of course, in some sense we are always inside the box of our own minds, since we cannot experience the world except through our individual brains.

Even though we cannot fill in all the blanks leading from the physical brain to the sensation of consciousness, we can make that leap plausible. In recent years, scientists and others have come to recognize activities we call emergent phenomena—behaviors of complex systems that are not evident in their individual parts. A good example is the way that certain groups of fireflies synchronize their flashing. As discussed in the essay "Fireflies," in a way not fully understood, some species of fireflies will begin flashing in unison when they congregate on a summer night. Similarly, our brains, composed of 100 billion neurons/fireflies, exhibit all kinds of spectacular behavior that cannot be explained or predicted in terms of individual neurons.

We human beings have evolved to where we are over millions of years. Now, with the exponential advance of technology, we have bypassed normal Darwinian evolution. Just consider eyeglasses and hearing aids and, rather recently, computer chips in the brains of paralyzed people that allow them to move robot arms by pure thought. Right under our noses, *Homo sapiens* is transitioning into *Homo techno,* part human and part machine. And the change is happening not over millions of years. It's happening in single human lifetimes, by our own inventions and technology. We are modifying our evolution by our own hand. We are remaking ourselves. What will remain of us *Homo sapiens* 500 years in the future? It is my hope that we will still feel awe when looking up at the night sky, that we will still write books and compose symphonies, that we will still fall in love, and even that we will still feel anger and jealousy and passion. And that we will still hope.

As one particular member of *Homo sapiens* living in the dawn of the Digital Age, one who has a scientific view of the world but also an appreciation of those human feelings that cannot easily be reduced to

zeroes and ones, a "spiritual materialist," I am grateful for sunsets and spider webs and hummingbirds and fall foliage and mists rising from the soil on cool early mornings. I am grateful for being part of that tiny fraction of matter in the cosmos that is alive, able to bear witness to this grand spectacle of a universe.

Acknowledgments

This book grew out of two experiences. Several years ago, when I was running by a field early in the morning, I noticed a mist rising from the ground and began thinking about what caused it. (See the essay "Morning Mist.") More recently, I was the host of a public television series in which I made the point that many amazing natural phenomena, including human consciousness, are the result of the actions of material atoms and molecules. In one of the episodes, I used the phrase "the miraculous from the material."

There is a lot of science in this book, and I take responsibility for any errors. I do want to thank several people for their help: Robert Jaffe, Kristen Bergmann, Lodovica Illari, and Anthony Roberts.

Notes

ATMOSPHERE

3 "You get up there": Alex Kotlowitz, "The Thin Blue Ribbon," *The Allegheny Front,* August 5, 2016.

3 Without an atmosphere: Rhett Allain, "What Would Earth's Temperature Be Like Without an Atmosphere?" *Wired,* February 3, 2023.

ATOMS

7 "It seems probable to me": Isaac Newton, *Optics,* book 3, part 1, trans. Andrew Motte and rev. Florian Cajori, in *Great Books of the Western World,* vol. 34 (Chicago: Encyclopaedia Britannica, 1987), p. 541.

9 Only a few years ago, in 2021: Zhen Chen et al., "Electron ptychography achieves atomic-resolution limits set by lattice vibrations," *Science* 372, no. 6544 (May 21, 2021): 826–31.

AURORAE

13 The oldest written records: Hisashi Hayakawa, Yasuyuki Mitsuma, Yusuke Ebihara, and Fusa Miyake, "The Earliest Candidates of Auroral Observations in Assyrian Astrological Reports: Insights on Solar Activity Around 660 BCE," *The Astrophysical Journal Letters* 884, no. 1 (October 7, 2019).

15 "The heavens were brilliantly illuminated": "Solar Storm 1859," SolarStorms.org, https://www.solarstorms.org/SS1859.html.

BIOLUMINESCENCE

17 "While sailing in these latitudes": Charles Darwin, *Narrative of the Surveying Voyages of His Majesty's Ships* Adventure *and* Beagle *Between the Years 1826 and 1836, Describing Their Examination of the Southern Shores of South America and the* Beagle's *Circumnavigation of the Globe,* vol. 3 (London: Henry Colburn, 1839), 190–91. See also: http://darwin-online.org.uk/content/frameset?viewtype= side&itemID=F10.3&pageseq=30.

18 "some objects of sight": Aristotle, *De Anima,* book 2, part 7, trans. J. A. Smith,

Notes

in *Great Books of the Western World,* vol. 8 (Chicago: Encyclopaedia Britannica, 1987), pp. 649–50.

19 Recent research by biologist Andrew Prevett: Cell Press, "Dinoflagellate plankton glow so that their predators won't eat them," Phys.org, June 17, 2019, https:// phys.org/news/2019-06-dinoflagellate-plankton-predators-wont.html.

BIRDS

21 "Remember that your flying machine": Leonardo da Vinci, *The Notebooks of Leonardo da Vinci,* vol. 2, comp. and ed. Jean Paul Richter (London: Constable and Company, 1970), pp. 278–79.

BUBBLES

29 Anyone who has seen a honeycomb: Thomas C. Hales, "The Honeycomb Conjecture," *Discrete and Computational Geometry* 25 (2001): 1–22.

DNA

33 "Then the even more important cat": James Watson, *The Double Helix* (New York: New American Library, 1969), p. 107.

ECLIPSES

35 The earliest known recorded eclipse: T. de Jong and W. H. van Soldt, "The Earliest Known Solar Eclipse Record Redated," *Nature* 338 (1989): 238–40.

FALLSTREAK HOLES

47 "stunned and confused": Sean Breslin, "A Rare Fallstreak Hole Was Spotted over Victoria, Australia, and Residents Were Stunned and Confused," Weather.com, November 4, 2014, https://weather.com/news/news/fallstreak-hole-australia -20141104.

FLOWERS

57 "long before I had attended": Charles Darwin, *The Effects of Cross and Self-Fertilization in the Vegetable Kingdom* (London: John Murray, 1878), p. 5.

58 "On an evolutionary scale": Randolf Menzel and Avi Shmida, "The Ecology of Flower Colours and the Natural Colour Vision of Insect Pollinators: The Israeli Flora as a Study Case," *Biology Review* 68 (1993): 82.

GLACIERS

67 "There is no protection against": Strabo, "The Alps," in *Geography,* vol. 1, quoted in David Bressan, "The discovery of the ruins of ice: The birth of glacier research," *Scientific American* (January 3, 2011).

GRAND CANYON

71 "At a distance of from one to twenty miles": "Letters of Major J. W. Powell to the *Chicago Tribune*," *Utah Historical Quarterly* 15, nos. 1–4 (1947). Powell's original journals are housed at the New York Public Library and at the Cline Library of Northern Arizona University.

HA LONG BAY

75 "a marvel of the earth erected towards the high skies," https://en.wikipedia.org /wiki/Hạ_Long_Bay.

HUMMINGBIRDS

79 "air within the air": Pablo Neruda, "Ode to the Hummingbird." The poem can be found at http://www.hummingbird-guide.com/pablo-neruda-hummingbird -poem.html.

MAMMATUS CLOUDS

92 A relatively recent article: Charles A. Doswell II, "Comments on 'The Mysteries of Mammatus Clouds: Observations and Formation Mechanisms,'" *Journal of the Atmospheric Sciences* 65, no. 3 (March 1, 2008).

MANDARINFISH

96 "when we see leaf-eating insects green": Charles Darwin, *The Origin of Species* (1859), chap. 4, in *Great Books of the Western World,* vol. 49 (Chicago: Encyclopaedia Britannica, 1952), p. 42.

MOON

99 "The Moon was but a chin": This and all Emily Dickinson poems from *The Complete Poems of Emily Dickinson,* ed. Thomas H. Johnson (Boston: Little Brown, 1960).

99 The Wakaranga people of Zimbabwe: Ulli Beier, *The Origin of Life and Death: African Creation Myths* (London: Heinemann Educational Books Ltd., 1966).

MORNING MIST

105 "I am dust particles in sunlight": Rumi, "Say I Am You," in *The Essential Rumi,* trans. Coleman Barks (New York: HarperCollins, 1995), p. 275.

PARAMECIA

109 "The explanation of everything is sought": Leo Tolstoy, *My Religion, On Life, Thoughts on God, On the Meaning of Life,* trans. Leo Weiner (New York: Colonial Press, 1904), p. 402.

110 "Among these streaks": Letter from Leeuwenhoek to Henry Oldenburg, first

secretary of the Royal Society, September 7, 1674, trans. in C. Dobell, *Antony van Leeuwenhoek and His Little Animals* (New York: Russell and Russell, 1958), pp. 109–10.

110 "I can clearly place before my eye": *The Select Works of Antony Van Leeuwenhoek,* trans. Samuel Hoole (London: G. Sidney, Black-Horse Court, Fleet-Street, 1800).

SATURN'S RINGS

123 "[Saturn] is surrounded by a thin, flat ring ": Christiaan Huygens, *Systema Saturnium* (The Hague: Adriaan Vlaq, 1659) p. 47.

SHOOTING STARS

132 "If a shooting start flashes": Judy K. Bjorkman, "Meteors and Meteorites in the Ancient Near East," *Meteoritics* 8, no. 2 (June 1973): 96. See also: https://www.academia.edu/37246135/METEORS_AND_METEORITES_IN_THE_ANCIENT_NEAR_EAST.

134 "The inhabitants of Charleston": *Richmond Enquirer* (Richmond, VA), November 19, 1833, at Chronicling America: Historic American Newspapers, Library of Congress, https://chroniclingamerica.loc.gov/lccn/sn84024735/1833-11-19/ed-1/seq-3/.

SNOWFLAKES

137 "I do not wonder at a snow-flake": Ralph Waldo Emerson, *The Conduct of Life,* vol. 6 (Ann Arbor: University of Michigan Library, 2006), p. 48, https://quod.lib.umich.edu/e/emerson/4957107.0006.001/66:16?.

137 On a spring day in 1936: A description of Nakaya's experiment, as well as general information on snow, can be found in Corydon Bell, *The Wonder of Snow* (New York: Hill and Wang, 1957).

138 The German astronomer Johannes Kepler: Kepler's work on snow and snowflakes is discussed in *Dictionary of Scientific Biography,* vol. 7 (New York: Scribner's, 1979), p. 299.

SPIDER WEBS

143 "The spider as an artist": Emily Dickinson, poem 1275, 1873, in *The Complete Poems of Emily Dickinson,* ed. Thomas H. Johnson (Boston: Little Brown, 1960).

SPIRAL PLANTS

150 In 2004, two mathematicians: Patrick D. Shipman and Alan C. Newell, "Phyllotactic Patterns on Plants," *Physical Review Letters* 92, no. 168102 (April 23, 2004).

STARS

155 "Does not the heaven arch itself": Johann Wolfgang von Goethe, *Faust,* trans. A. Hayward (New York: D. Appleton and Company, 1840), p. 141.

155 "And having made [the universe]": Plato, *Timaeus,* trans. Benjamin Jowett, in *Great Books of the Western World,* vol. 7 (Chicago: Encyclopaedia Britannica, 1952), p. 452.

156 "there can be an infinite number": Giordano Bruno, "Second Dialogue," in *On the Infinite Universe and Worlds,* trans. Scott Gosnell (Port Townsend, WA: Huginn, Munnin & Co., 2014), p. 76.

158 "If 5 per cent of a star's mass": Arthur Eddington, "The Internal Constitution of the Stars," *Nature* 106 (September 2, 1920): 19.

SUNSETS

161 "She sweeps with many colored Brooms": Emily Dickinson, poem 219, 1861, in *The Complete Poems of Emily Dickinson.*

VOLCANOES

165 "Through the glasses, the little fountains": Mark Twain, *Sacramento Daily Union,* November 16, 1866, http://www.twainquotes.com/18661116u.html.

167 "The cloud could best be described": Letter from Pliny to Tacitus, in Alwyn Scarth and Jean-Claude Tanguy, *Volcanoes of Europe* (New York: Oxford University Press, 2001), p. 19, https://igppweb.ucsd.edu/~gabi/sio15/lectures/volcanoes/pliny.html.

HUMANS

182 "How do I love thee": Elizabeth Barret Browning, Sonnet 43 (1850).

Illustration Credits

A Note About the Author

Alan Lightman worked for many years as a theoretical physicist. He is the author of seven novels, including the international best seller *Einstein's Dreams* and *The Diagnosis,* which was a finalist for the National Book Award. He is also the author of a memoir, three collections of essays, and several books on science. His work has appeared in *The Atlantic, Granta, Harper's Magazine, The New Yorker, The New York Review of Books, Salon,* and *Nature,* among other publications. He has taught at Harvard and at MIT, where he was the first person to receive a dual faculty appointment in science and the humanities. He is currently professor of the practice of the humanities at MIT. He lives in the Boston area.